# Conten

# A–Z

OF

# LEICESTER

PLACES - PEOPLE - HISTORY

Stephen Butt

AMBERLEY

First published 2017

Amberley Publishing
The Hill, Stroud, Gloucestershire, GL5 4EP
www.amberley-books.com

Copyright © Stephen Butt, 2017

The right of Stephen Butt to be identified as
the Author of this work has been asserted in
accordance with the Copyrights, Designs and
Patents Act 1988.

ISBN  978 1 4456 6478 1 (print)
ISBN  978 1 4456 6479 8 (ebook)

British Library Cataloguing in Publication Data.
A catalogue record for this book is available
from the British Library.

Origination by Amberley Publishing.
Printed in Great Britain.

# Introduction

Incorporating the first and last letters of the alphabet into the title of a book might suggest the intention of completeness or the promise of an organised and comprehensive survey of Leicester as formal as a telephone directory, but the history of a place can never be complete. John Nichols took at least twenty years to compile his monumental *History and Antiquities of the County of Leicester* (1795–1815). A century later, the first volume of the *Victoria County History of Leicester* was published, and four further volumes followed, but the project is still far from finished, a further century having now passed.

Leicester is a fascinating city. Historically, there is continuity from the tribal peoples who were here before the Romans to the people of the present day. Buildings and written records show the gradual transition of power and influence from military might to the merchant classes, the religious orders and the development of democratic local government. Pioneers of industry, education, philanthropy, politics and science have all made their mark, as have musicians, writers, actors and even historians.

This modest volume is an introduction to all that has made Leicester the city it is today – from the famous and notorious to the unusual. There are also those who have saved lives through their discoveries, informed through their writing, and entertained on the stage and in the sporting arena.

Leicester's historical secrets are worth discovering. Look anywhere in the city and there is an example of its fascinating heritage just moments away. From the very impressive Jewry Wall, the exposed remains of the Roman baths and the charming Cathedral Church of St Martin, to the Norman undercroft beneath the modern BBC studios; from the castle guarding the River Soar, to the Heritage Centre of De Montfort University in the solid red-brick Hawthorn Building, where arches from the lost Church of St Mary of the Annunciation in the Newarke can be seen, under whose shadows the body of Richard III was lain before his hasty burial in the nearby friary.

Leicester's long history and heritage lies, below the surface, buried deep in the culture, legends, street names and language of the area. It's all worth rediscovering and revisiting.

The first writer to take readers on a walk around Leicester was Susanna Watts, whose little guidebook was published in 1805. It provided an affectionate and lively account of the town in her time and the expansion that was just beginning. Miss Watts' concluding remarks from two centuries ago will serve admirably to conclude this introduction:

We beg (the reader) will accept a friendly adieu: and a wish, that as he quits the town thro' which we have conducted him, and which we have endeavoured to represent in a view not unworthy the attention of a mind that seeks for more than mere passing ideas of amusement, he may not consider that time as prodigally spent which he has passed in his walk through Leicester.

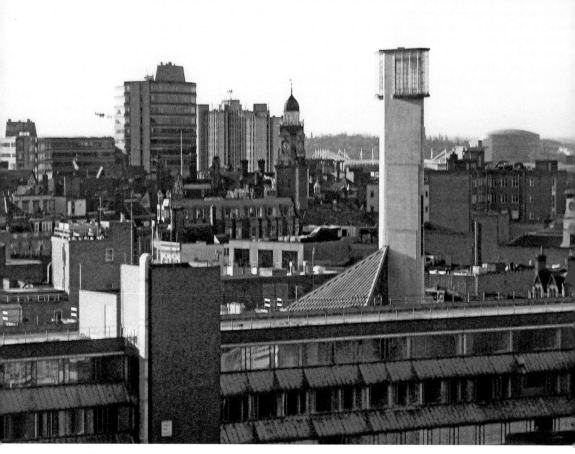

A view of Leicester in 2010, south from Belgrave Gate.

# Abbey Park

Abbey Park is a Victorian creation but its history began in 1143 when Robert de Bossu, 2nd Earl of Leicester, founded the Augustinian Abbey of St Mary de Pratis on this land outside the town.

During the Dissolution of the Monasteries, the abbey and lands were granted to the Marquess of Northampton, who later sold it to William Cavendish, 1st Earl of Devonshire. In the seventeenth century he built a large house nearby with stone removed from the ruins. The house was later used by Charles I during the Civil War and was deliberately gutted and set on fire by his forces after his departure. The charred ruins remain today.

Little exists of the abbey today but its approximate 'footprint' is marked within the grounds. In recent years, much more knowledge of the abbey has been gained from archaeological digs, which have been used to train students at the University of Leicester.

Plans to convert the 57 acres into a public park began in 1879 as part of flood defences along the River Soar. This involved widening and deepening the river, the excavated soil being used to landscape the parkland. Stone weirs, locks and three new bridges were also constructed, more than 33,000 new trees were planted and an artificial lake was created. The park was opened by the Prince and Princess of Wales on 29 May 1882, and extended in 1932.

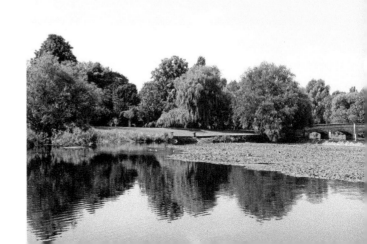

Abbey Park. The Victorian concept of leisure and wholesome recreation.

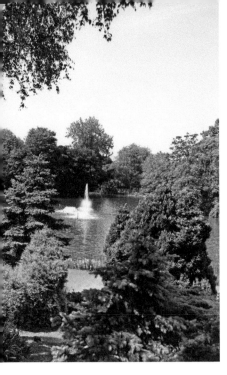

Leicester's Abbey Park, an open space for those who live and work in the city centre.

# All Saints Church

All Saints is probably one of the six ancient Leicester churches listed in the Domesday Book. In 1143 it was given to Leicester Abbey. The church was enlarged during the following century and, in 1583, during outbreaks of the plague, the assizes were held here.

By the nineteenth century the church fabric was suffering from neglect, which led to several separate refurbishments. In the 1960s, the construction of the central ring road cut the church off from the centre of the city. The congregation declined and the chancel was divided from the rest of the church to form a smaller place of worship. The church closed in 1982 and was declared redundant on 1 January 1983. It was handed over to the Churches Conservation Trust on 8 July 1986.

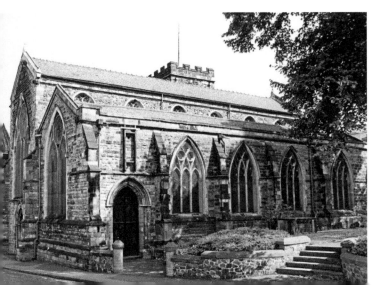

All Saints, one of Leicester's ancient churches, now closed but still serving in its parish in other roles.

The clock above the south door dates to the time of James I. It was removed from the front of the church in 1875, repaired and then reinstalled in 1900 in its present position. It bears a panel painted with representations of Time with his scythe. At the top are arches through which two carved 'jacks', dressed in Jacobean costume, emerge to strike the quarters. The present figures are replacements, the originals having been stolen in the early 1970s. In 2009 the clock was again fully refurbished, the cost being borne by the Leicestershire and Rutland Freemasons.

## The Austral

Walter E. Sturgess set up his bicycle business in a shop on the corner of Cranmer Street and Shaftsbury Road, just off the Narborough Road, in 1897. As well as making, selling and repairing bicycles, Sturgess designed his own cane work bicycle trailers. Earlier, he had travelled to Australia intending to make his fortune, but met a young woman from Leicester whom he married. They returned to their home city where Walter established his business, calling his trailer the 'Austral'. Walter's business prospered. He moved to larger premises in Narborough Road and then to Braunstone Gate. He began selling motorcycles and then cars. Later, the company would have plush showrooms and garages in Charles Street and elsewhere in the city. Today, Sturgess is one of the largest dealerships in Leicester and it is still a family business.

Bicycles are synonymous with Leicester. A number of technical innovations have taken place here. One such development was the recumbent bicycle, on which the rider sat back in a recumbent position similar to some Harley Davidson motorcycle designs. It is also believed that the pneumatic tyre was invented here before being developed by Dunlop. Currys and Halfords are major retailers who began in Leicester by making and selling bicycles. For many years Abbey Park was the venue for bicycling events and races, and today the city is becoming more 'friendly' to pedal power, with a network of cycle lanes and special events.

Walter Sturgess's cycle shop on the corner of Cranmer Street and Shaftsbury Road.

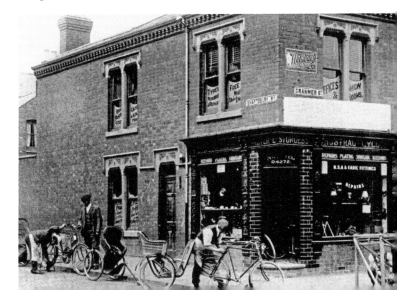

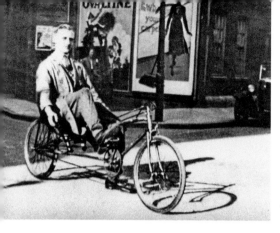

A recumbent bicycle on display outside Walter Sturgess's shop.

# Hugh Aston

Little is known of the early life of this important Tudor composer, but after becoming the master of the choristers of the Hospital and College of St Mary of the Annunciation in the Newarke, it seems that Aston lived and worked for the rest of his life in Leicester. He is known to have occupied a house just outside and opposite the Newarke Gateway in Southgates, and that in later life became a member of the town council and an alderman representing the Southgates Ward. The Newarke College had gained a strong reputation for its music, and Aston was recommended to Cardinal Wolsey for the post of director of music at his then new Christchurch College, but possibly turned down the invitation. In 2010 De Montfort University's Faculty of Business and Law, adjacent to the Newarke Gateway and only around 100 metres from the site of Aston's house, was opened and named the Hugh Aston Building. The event was marked by performances of some of his music in the Chapel of Trinity House, formerly Trinity Hospital, where Aston would once have worked and worshipped. The college was dissolved in Easter 1548, after which Aston received a state pension. He was buried on 17 November 1558 in St Margaret's Church.

The Newarke Gateway to the college where Hugh Aston was director of music in the sixteenth century.

# The Attenborough Building

One of the three high-rise towers on the University of Leicester campus, and home to the university's departments of Arts, Humanities, Law and Social Science, the Attenborough Building was named after Frederick Attenborough, father of the late Lord (Richard) Attenborough and the distinguished naturalist Sir David Attenborough. Frederick was principal of the University College of Leicester from 1932 until 1951. The building was opened in 1970 by his other son, John, on the same day that Richard and David received honorary degrees.

It stands on the site of a former hostel where nurses who worked at the nearby asylum lived. The building was designed by Ove Arup and constructed by John Laing. Originally, three identical towers were planned but only one was built.

Although born in the London area, David and Richard Attenborough have maintained close links with the city in which they grew up. Sir David has spoken of the rich cultural experience of his boyhood in Leicester and the inspiration gained by visiting the natural history collection in the New Walk Museum & Art Gallery, which now holds Lord Attenborough's fine collection of Picasso ceramics. Opened in 1997 by the late Princess Diana, the nearby Richard Attenborough Centre for Disability and the Arts was created from a campaign championed and led by Lord Attenborough, who was actively involved in arts and disability.

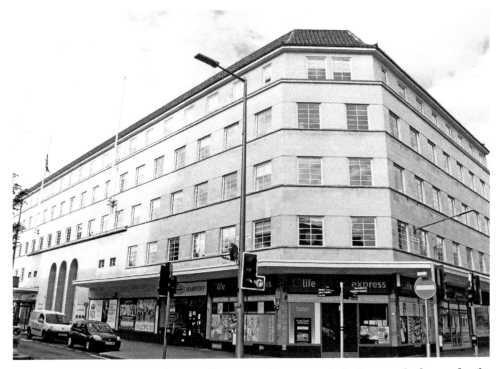

Attenborough House, Leicester's City Hall, 1930s art deco restored, also honours the famous family.

# Isaac Barradale (1845–92)

Regarded as one of England's finest Arts and Crafts architects, there are still many buildings in Leicester that are testament to Isaac Barradale's skills. He had an important influence on the appearance of Leicester, especially in the Stoneygate area where he popularised the English Domestic Revival style for housing. In Stanley Road he designed and built two very large houses, Elmhurst (more familiarly the Croft Hotel) and Carisbrooke, named after two sisters and paid for by their doting father. One of several well-known owners of Carisbrooke was Sir Alfred Corah of the famous Leicester textile manufacturing family.

It was Barradale to whom Ernest Gimson, the renowned Arts and Crafts architect and furniture maker, was articled between 1881 and 1885. Barradale's 'Leicester style' was characterised by tall gables, rough cast walls, heavy timbering and small-paned windows.

In the city centre the department store, occupied until 2017 by Fenwicks and designed by the previous occupant Joseph Johnson, is the largest Barradale building in Leicester. The former Leif's pawn shop in Wharf Street, now refurbished and extended as residential apartments, is another interesting design, as is No. 12 Knighton Park Road, the former residence of Leicester artist Wilmost Pilsbury, who was the first headmaster of the Leicester College of Art. Pilsbury and Barradale worked together

Carisbrooke and Croft in Stanley Road. Two houses characterising Isaac Barradale's Arts and Crafts style.

on the design, which included a studio illuminated by natural light and patterns in the plaster above the windows created by the artist.

Barradale's practice was based at St George's Chambers in Greyfriars. The building, which he designed himself, still stands and has changed little since Barradale's days.

# BBC Radio Leicester

The brainchild of former BBC war correspondent Frank Gillard, Radio Leicester was the first UK mainland local radio station and began broadcasting on 8 November 1967 from small studios in Epic House, an office block in Charles Street. The station's first manager, Maurice Ennals, faced opposition from both within the BBC and the local press, who saw the station as competition.

The station broadcast only on VHF (FM), which limited its potential audience, and in the early days there were only about six hours of locally made programmes each day. By the time Radio Leicester moved in 2005 to its new studios in St Nicholas Place, it was on the air locally for over fourteen hours every day and had an audience of nearly a quarter of the population of Leicester and Leicestershire. From the start, Radio Leicester broadcast special programmes for the Asian community, which developed into the present-day BBC Asian network.

Many familiar names began their broadcasting careers in Leicester including the BBC cricket correspondent John Agnew MBE, former Radio One DJ Adrian Juste and BBC *Countryfile* presenter Charlotte Smith.

Beneath the present studios lies a Norman undercroft constructed partly from Roman bricks. It has been conserved, and the remains are visible through specially constructed glass floor panels.

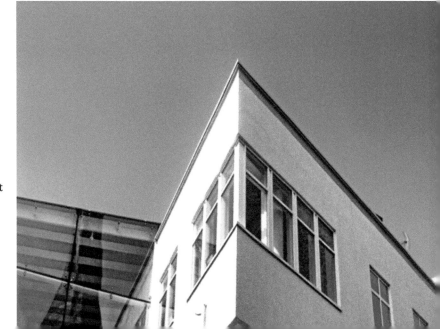

Striking angles at the BBC studios in St Nicholas Place. Note the reflection of the cathedral spire.

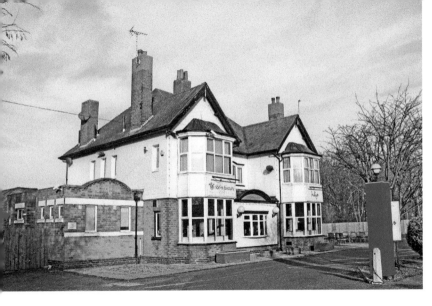

The former Fosseway pub where the Showaddywaddy story began.

# Dave Bartram

Although a solo performer in his own right, Dave Bartram will be forever associated with Showaddywaddy. The band was formed in 1973 when two groups, Choise and the Golden Hammers, who both played at the Fosseway pub in Leicester, decided to join together, becoming an eight-piece band with two sets of drummers, bassists and soloists. In February they won £1,000 in a talent contest at Bailey's nightclub in the Haymarket Centre, Leicester, and just weeks later, on 1 September 1973, they undertook their first professional appearance at the Dreamland Ballroom in Margate.

Their first single, 'Hey Rock and Roll', written by the group, was released in April 1974 and reached No. 2 in the UK Singles Chart. In all, the group has had ten Top Ten singles, but just one No. 1 ('Under the Moon of Love' in 1976), and have spent 209 weeks in the UK Singles Chart.

Dave Bartram left the line-up in December 2011 after thirty-eight years fronting the band. His last appearance with Showaddywaddy was at the Kings Hall Theatre in Ilkley, West Yorkshire, and their last Leicester appearance together was at the Summer Sundae Festival in August 2011. He continues to act as their manager, a role he has fulfilled since 1986.

Showaddywaddy continues to tour with around 100 gigs every year. In 2013 they undertook a five-month 40th anniversary tour.

# Black Annis

Although the legend of Black Annis may be much older and not from Leicestershire, this famous witch has been part of local legend since the mid-nineteenth century. She is said to be a blue-faced crone with iron claws and a taste for humans, particularly children. She lives in a cave in the Dane Hills area, and enters the city using tunnels.

One of her favourite places is the Turret Gateway between the Newarke and the castle precincts where, it is claimed, she will leap out on those who pass through the gateway at midnight.

The prominent religious academic Professor Ron Hutton suggests she may be based on Agnes Scott, a nun who lived a life of solitary prayer in the same area and is buried in the Leicestershire village of Swithland. She also sometimes appears in the form of a cat, which links to a local springtime ritual when a dead cat would be dragged before a pack of hounds in front of her bower to celebrate the end of winter.

In living memory, children in Leicester were warned by parents to behave with the threat that 'Black Annis will get you'. It is even said that a particular form of locked window on many local cottages was designed to prevent the witch from reaching in to remove babies and young children from their homes.

## The Blue Boar Inn

The Blue Boar was a large coaching inn on the former High Street that had been built in the mid-fifteenth century close to the High Cross. Before the Battle of Bosworth it was known as the White Boar. The landlord changed the name to the emblem of Henry VII when news of Richard III's demise reached the town. On his previous visits to Leicester Richard had stayed at the castle, but by 1485 the building was beginning to

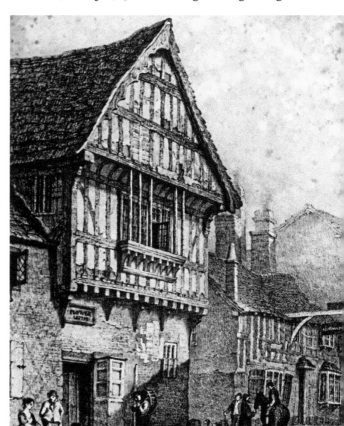

The Blue Boar Inn. John Flower's etching of *c.* 1826.

fall into disrepair, so on 20 August 1485 the king rode into Leicester from Nottingham and stayed at the Blue Boar before riding out to Bosworth Field on the following day.

The inn was demolished in 1836 and a new pub with the same name was built 200 yards south on Southgate Street. This was demolished in the 1970s. A Travelodge now stands on the site of the earliest Blue Boar, and in 2013 a plaque was unveiled on the building to record its links with this dramatic moment in Leicester's history. A new pub with the same name opened in Millstone Lane in 2016.

# Bonner's Lane

The main approach to the Newarke from the city for motor vehicles today is by Bonner's Lane, a turning off Oxford Street. The lane is named after an infamous bishop of London, Edmund Bonner (c. 1500–69), who became notorious as 'Bloody Bonner' for his role in the persecution of heretics under the Catholic government of Mary I. His association with Leicester is as Cardinal Thomas Wolsey's chaplain. He was present in Leicester when the cardinal died in 1530. Bonner himself died in prison during the reign of Elizabeth I and was buried secretly at night in a Southwark churchyard to avoid hostile protests.

It is probably true that no other bishop of that period has been so despised and the target of such hatred. 'Go beast, into hell, and find your friends there, for we are none of them. I killed but one man upon a provocation, and do truly repent of it; but you have killed many persons of all sorts, without any provocation from them, and are hardened in your impenitence' was how one fellow prisoner in the Marshalsea Prison addressed him.

However, despite his reputation, a primary school and two roads in the East End of London are named after him.

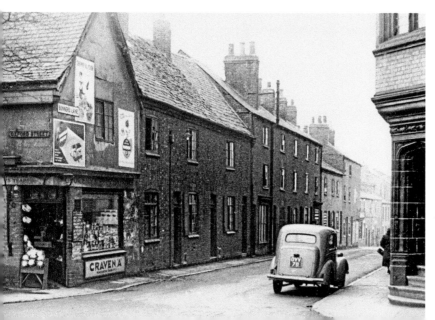

Bonner's Lane, at its junction with Oxford Street, photographed around 1950.

# C

## William Carey

The founder of the Baptist Missionary Society, William Carey, moved to Leicester in 1789 from his native Northamptonshire to become the minister of the Harvey Lane Chapel. The building was on the corner of Harvey Lane and Thornton Lane. Carey lived in a small cottage opposite, supplementing his income by shoemaking and running a small school.

He was mainly self-taught, but became fluent in Greek, Latin and Hebrew as well as knowledgeable in the sciences and history. In Leicester he wrote *The Enquirer*, which is still regarded as the finest missionary treatise ever written. The Baptist Missionary Society was founded in 1792 largely as a result of Carey's influence, and in 1793 he travelled with his family to India. He worked as a foreman in an indigo factory in Calcutta before setting up a church and moving on to Serampore in 1799.

Carey was made professor of Sanskrit and Bengali at Fort William Cottage in Calcutta in 1801, and in 1805 opened a mission chapel there. He was a prodigious translator, responsible with others for translating the Bible into six Indian languages and the New Testament into twenty-three more. He died at Serampore in 1834.

The opening of the first William Carey Museum in Harvey Lane.

The Harvey Lane Chapel was destroyed by fire in 1921. It was rebuilt as a memorial hall but this was demolished in 1963. His cottage was cleared at the same time to make way for the Southgates Underpass and Holiday Inn development. The various relics that had previously made up a small museum in Carey's Cottage are now at the Central Baptist Church in Charles Street.

# Thomas Cook

Thomas Cook was born in Melbourne in Derbyshire, and after working as a travelling missionary across the East Midlands, he married the daughter of a Rutland farmer and settled in Market Harborough. While travelling from Market Harborough to Leicester for a temperance rally, he realised the potential of using the developing railway system to help social reform. 'The thought suddenly flashed across my mind', he later wrote, 'as to the practicability of employing the great powers of railways and locomotion for the furtherance of this social reform.'

Cook proposed that a special train be hired to take temperance supporters to a meeting in Loughborough. He contacted the Midland Railway, and on 5 July 1841 nearly 500 local people undertook the journey from Leicester's Campbell Street station to Loughborough and back.

The event was successful in social terms and as a financial proposition. For the next four years Cook organised many similar excursions, providing thousands of workers in the towns of the Midlands with their first experience of railway travel, and offered them an environment away from the lure of alcohol.

Cook's first commercial venture, an excursion from Leicester to Liverpool, took place in 1845. Setting the standards for his future business success, he planned each aspect of the project in great detail, personally travelling the route. His careful attention to detail and his ability to find ways of advertising the low cost of tickets ensured that the venture was successful and the first step towards a tourism business of international renown.

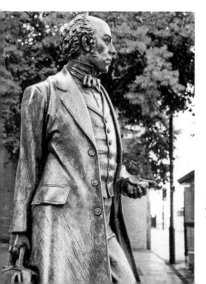

James Butler's statue of Thomas Cook, the father of world tourism.

# The Clock Tower

In 1867 a group led by John Burton, the owner of a nearby photography business, raised funds for a landmark building at this important intersection of routes. The challenge was to construct 'an ornamental structure ... in height from 35 to 40 feet to contain four illuminated dials, four statuettes or medallion busts of ancient benefactors to the town, with a platform around 18 feet square, and lamps as a safeguard to passing pedestrians.'

Over 100 designs were submitted. Four hundred and seventy-two subscribers contributed a total of £872 2s 9d with a further £1,200 from the Corporation. The tower was built in the following year by Leicester architect Joseph Goddard using stone from Ketton in Rutland and a base of granite from nearby Mountsorrel. The columns are in polished Peterhead granite and serpentine. Facing outwards from the tower are four statues of Portland stone depicting 'sons' of the town, Simon de Montfort, William Wyggeston (spelt 'Wigston' on the tower), Thomas White and Gabriel Newton.

By the 1960s, the increase in traffic led to the area being described as 'Leicester's Piccadilly Circus'. An unconfirmed story tells of the editor of the *Leicester Mercury* facing delays in delivering newspapers to street vendors because of the traffic, and asking Chief Constable Robert Mark to act. Mark, it is said, responded by inventing traffic wardens.

The clock tower was restored in 1992 by local architects Pick Everard to mark their 125th anniversary. Recently, Leicester City Council has removed unnecessary street furniture and is providing new landscaping.

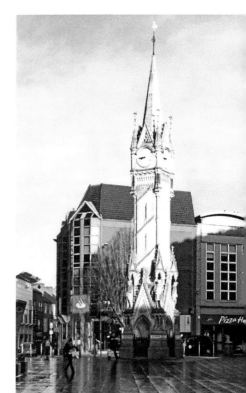

Leicester's iconic clock tower, designed by Joseph Goddard and constructed in 1868.

# Nathaniel Corah

Nathaniel Corah was born in 1777 to a farming family. He began his textile empire by buying items of clothing from Leicester framework knitters to sell at markets in Birmingham. By personally selecting each item, he established a level of quality control that became recognised by his customers. On Saturday mornings he would purchase the goods offered to him in an upper room of the Globe Inn in Leicester's Silver Street, which he would then transport to a small warehouse in Birmingham.

The project was a success and by 1824 Corah acquired buildings in Leicester's Union Street, which were extended in 1827. Corah's sons, John, William and Thomas, joined the business, which was then trading as Nathaniel Corah & Sons. This far-sighted move ensured the firm's future development because just two years later, Nathaniel Corah died at the age of fifty-one.

By 1866 over 1,000 people were working at the new St Margaret's factory, and the buildings had been extended twice. Originally, a factory yard stretched north as far as the canal but by 1941 there had been no less than nineteen extensions to the original building taking up all available land.

The company adopted an image of St Margaret. The emblem was patented on the first day of the 1875 Trade Marks Registration Act, and so is the oldest trademark for knitted goods in the world. For many years her statue stood high on the external wall of the factory, facing Vaughan Way. After the demise of the company and the sale of the buildings in the 1990s she was removed and now stands in St Margaret's churchyard facing St Margaret's Way.

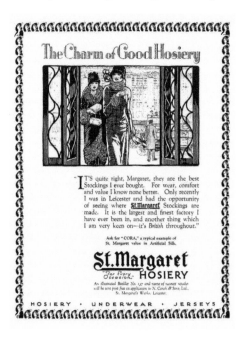

An advertisement for Corah stockings in *The Queen* magazine.

# D

## Simon de Montfort

Simon de Montfort arrived in England in 1229 to claim the title of the Earldom of Leicester. Little is known about his childhood. His date of birth is not recorded, but at around the age of ten he was with his parents at the Siege of Toulouse in 1218 where his father was killed.

His claim to the Earldom of Leicester came through his grandmother Amicia de Beaumont, who was a daughter of the 4th Earl of Leicester, and had, with her sister Margaret, co-inherited her father's estates. Amicia and Margaret's mother, Petronilla, was either the granddaughter or great-granddaughter of Hugh de Grentmesnil, the first occupier of Leicester Castle.

But was de Montfort a reformer? Was he a Parliamentarian? Was 'right' on his side during the conflicts in which he was involved? Centuries later, it was the English Civil War that challenged historians to reopen the debate into de Montfort's legacy. Parliamentarians argued that the main cause of the Barons' War had been Henry III's unfair taxation arising from his neglect of government, and they saw de Montfort as a liberating influence, but emphasised that his principal aim was to destroy the authority of the monarchy.

The effigy of Simon de Montfort on Leicester's clock tower.

The available evidence indicates that de Montfort remained preoccupied with his own personal advancement and his belief in the rightness of his ideas, and that his capacity for violence remained present throughout his life.

It is also thought unlikely that he ever came to Leicester. However, his name lives on, not only with the university but also in De Montfort Street, the De Montfort Hall, the once-famous De Montfort Knitwear Co. and countless organisations based in Leicester from health centres to housing associations.

# De Montfort University

The campus of De Montfort University has grown to dominate the Newarke, but the buildings that represent the origins of this institution are still standing and in use. It grew from a need for a school that 'would be able to afford authoritative instruction in art to the people of Leicester'. A public meeting was called in October 1869 and by March of the following year the Leicester School of Art had been formed, with lessons being held in an old warehouse.

At the same time, Revd James Went, headmaster of the Wyggeston Boys' School in Highcross Street, began a series of technical classes that developed into the Leicester Technical School, founded in 1882. These two organisations merged in 1897 to form the Leicester Municipal Technical and Art School, established up by the Leicester Corporation. The school was renamed as the Leicester College of Arts and Crafts and the Leicester College of Technology in 1929.

De Montfort University's Hawthorn Building, built in four stages between 1897 and 1937.

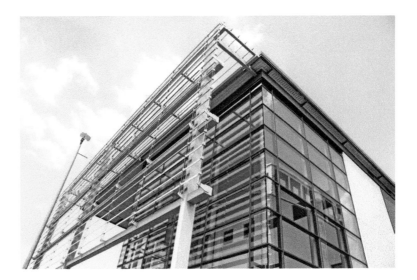

The changing face of the Newarke: De Montfort University's Student Union building.

In the post-war years, new buildings were constructed and the character of the Newarke changed once again. In 1969 the colleges became Leicester Polytechnic. A former hosiery factory facing Oxford Street was purchased and converted into the Clepham Building, and the institution merged with the City of Leicester College of Education. The happy juxtaposition of new and old buildings of many styles, reflecting the history of the institutions, has brought a new vibrancy to this area.

# Dryad Handicraft

Dryad is a name that is familiar to most people who can recall handicraft lessons in their primary school years in the later decades of the twentieth century. This well-known Leicester company supplied handicraft materials and revolutionised the way in which such crafts were taught to children.

The company was set up by Harry Hardy Peach, a skilful and far-sighted man who combined entrepreneurial business ability with a desire to help and support the less privileged in truly practical ways. His family roots were in Nottinghamshire but he was born in Canada, arriving in the Oadby area of Leicester at an early age when his family decided to return to England. He attended Wyggeston Boys' School and then Oakham School.

Through his friend and colleague Benjamin Fletcher, the principal of the Leicester School of Art, he had discovered the Arts and Crafts Movement, especially the work of William Morris. Peach went on to use handicrafts as occupational therapy rehabilitation for wounded ex-servicemen during the Second World War. Together, Peach and Fletcher established Dryad Furniture in 1907 in Belvoir Street. Within four years, their workforce had grown to fifty and in 1912 they moved to larger premises in St Nicholas Street and also set up a further company, Dryad Metal Works.

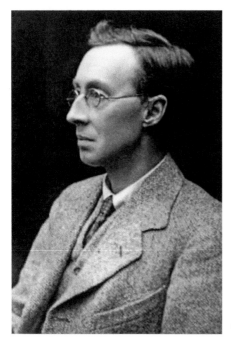

*Left*: Harry Hardy Peach (1874–1936), the inspiring founder of Dryad Handicraft.

*Below*: Cane furniture making in the Dryad Works near Sanvey Gate in the 1940s.

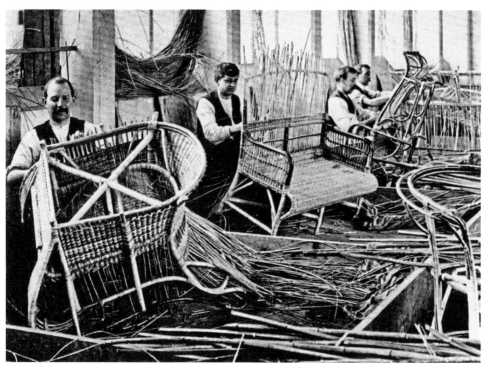

# E

## Every Street

The small street that runs along the side of Town Hall Square opposite the Town Hall was once called Municipal Square East. Today it is Every Street, although some older Leicester residents are still not aware of this modern name. It was here that Hansom cabs would park up, in the same way that taxis now wait at railway stations, to take passengers on to their destinations. It became the town's main interchange, with visitors arriving on stagecoaches along the London turnpike, changing to cabs that could take them on to every part of Leicester. A large sign indicating the cost of the fare to every street in the town was erected here. There is, inevitably, a local joke that begins 'How long does it take to walk down every street in Leicester?'

## Englebert Humperdinck

Arnold George Dorsey was born in India, one of ten children born to Mervyn and Olive Dorsey. The family moved to England and to Leicester in 1947, and by the 1950s Dorsey was playing saxophone in local clubs. He later adopted the stage name 'Gerry Dorsey' after performing a successful musical impression of Jerry Lewis.

Dorsey struggled to gain success as a singer for many years until his former roommate Gordon Mills, by then a successful manager of performers, including Tom Jones, suggested he changed his name to the more noticeable Englebert Humperdinck. The change, coupled with the particularly fine ballad 'Release Me', gave him the success he had been seeking. The record, released in 1967, was in the Top 50 charts for fifty-six weeks. At the height of its popularity, it sold 85,000 copies every day.

Englebert has enjoyed a long career in popular music in which, as well as a string of successful singles, he became an established cabaret stage artist particularly in Las Vegas and other world-renowned venues. In 2009 he was given the Honorary Freedom of Leicester by Leicester City Council, and in 2012 he represented the United Kingdom in the Eurovision Song Contest at the age of seventy-six. For some years he has lived in the USA but has always maintained a home in Leicester.

# John Flower

Known as 'the Leicestershire Artist', John Flower was baptised at St Mary de Castro in October 1793. He came from a family that had owned the Castle Mill on the River Soar for several generations. In 1806 he was apprenticed to a framework knitter, but his potential artistic talent was noticed, which led to lessons in London from Peter de Wint (1784–1849).

On returning to Leicester as a qualified artist, Flower was able to work as a teacher of drawing. He worked chiefly in watercolours, pencils and wash. His pictures of buildings are seen by many to be without equal. Indeed, were it not for Flower's drawings of the town (published in *Views of Ancient Buildings in the Town and County of Leicester* in 1826) the knowledge we have of the buildings of eighteenth-century Leicester would not be so great. A successful artist, he was able to commission his own home at No. 88 (now No. 100) Regent Street, which was designed for him by the local architect Henry Goddard.

The home in Regent Road of artist John Flower, designed in partnership with Henry Goddard.

He was known as a good-natured and friendly man. His output was considerable, and, with his wife, he travelled to neighbouring counties and as far as North Wales in search of subject matter.

He died on 29 November 1861 at his home. A blue plaque commemorates the building's association with the artist. He was buried in Welford Road Cemetery, the funeral service having been conducted by Revd Charles Berry of the Great Meeting, where Flower had been a member for over forty years.

# Emily Fortey

Politics and society in Leicester have been influenced by several remarkable women who were successful in breaking down the barriers that had previously prevented their voices from being heard in a male-dominated world.

Emily Fortey was the first female Labour councillor to be elected in the city. She was also elected to the Board of Poor Law Guardians and was vice president of the Leicester Temperance Society.

She was born in London in 1866 and studied at Bristol University and the London School of Economics. She also trained as a sanitary inspector and was a qualified midwife.

She moved to Leicester in 1909, becoming actively involved in Labour politics, though often clashing with the (male) Labour leadership over issues such as her opposition on religious grounds to birth control. During the First World War she undertook voluntary war work in France.

At times, Emily Fortey's strong principles led her to adopt unorthodox strategies to address what she saw as unfair social policies. Her Catholic faith was also important to her, and she often wore clothing similar to that of a nun. She died in 1946.

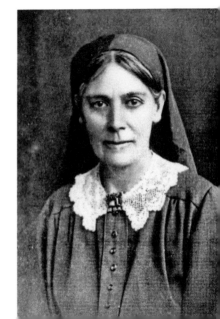

The remarkable Emily Fortey (1886–1946), politician and councillor who chose to wear a nun's habit.

# Stephen Frears

A film director of international renown, Stephen Frears has also been immortalised in the line 'Mr Frears had sticky out ears' from the song 'Lily the Pink' recorded by The Scaffold in 1968. Frears worked with the group early in his career.

He was born in Leicester. His father was a general practitioner and accountant and his mother was a social worker. He studied law at Cambridge but then worked as an assistant director on films such as *If* and *Morgan!*. Most of his early career was in television, producing series for the BBC such as *Play for Today* and Alan Bennett plays for ITV.

Frears came to international attention in the 1980s as an important director of British and American films. He became regarded as the director who told stories about good and bad people and others in their world, and of the conditions they face in a world that they must adapt to.

His production of *My Beautiful Laundrette* gave him popular and critical recognition. It received a nomination for an Academy Award and two nominations for BAFTA Awards. Frears also directed the successful British film *Prick Up Your Ears* about Leicester playwright Joe Orton, and made his Hollywood debut with *Dangerous Liaisons*. His film *The Queen* depicted the death of Princess Diana. It achieved immense critical acclaim, box-office success and awards. Frears received his second Academy Award nomination for his direction.

Frears holds the David Lean Chair in Fiction Direction from the National Film and Television School, where he often teaches.

# Friar Lane

Friar Lane is named after Leicester's Greyfriars, and has been known by this name since at least 1391, and certainly existed before that date. Friars, unlike monks, were not secluded communities. The friars worked and ministered outside their precincts, within the community. Leicester was also home to a Dominican community (Blackfriars) and a Carmelite community (Whitefriars). Significantly, most of the ordinary friars were buried in humble locations such as beside the nearby streets. Only individuals important to their community, such as founders and sponsors, were buried in hallowed places such as the choir of their church.

Friar Lane has several high-status residences from the eighteenth and nineteenth centuries. Number 17, built in 1750 for William Bentley and also known as Dr Benfield's, has been described as Leicester's most lavish eighteenth-century house and 'the handsomest Georgian house now left in the old town'. The County Offices, on the corner of Greyfriars and Friar Lane, were completed in 1937, to the designs by Pick, Everard and Keay.

# G

## The Guildhall

There is an unproven claim that William Shakespeare discovered the story of King Leir (or Lear) while performing in Leicester's Guildhall with a travelling theatre troupe. The earliest part of the Guildhall was built in around 1390 as the meeting place of the Guild of Corpus Christi, which was founded in 1343. It also provided accommodation for a chantry priest who would pray for the souls of guild members in St Martin's Church.

The fabric of the Guildhall, with its several wings, staircases and balconies, reflect the different periods in its history and the activities that were carried out here. These include the construction of quarters for the chief constable in 1840, which was later used as cells. Leicester's first police station was opened in the Guildhall in 1836. The Guildhall also housed the third-oldest public library in England, established in 1632 in the east wing of the building.

Today, this fascinating building is used for concerts, wedding receptions and performance events, as well as housing an exhibition of artefacts relating to medieval

The Guildhall, built by the Guild of Corpus Christi.

Leicester. It is also said to be the city's most haunted building, with claims that no less than five ghosts have been seen and identified.

Important decisions were made within this building during the English Civil War, and in 2014 the announcement that the skeleton found in the Greyfriars area nearby had been confirmed as being the remains of Richard III was made here in the Great Hall and televised live around the world.

# Guildhall Lane

This street has had many different names in its long history including Holyrood Lane, Kirk Lane, Kirk Gate, St Martin's Church Lane and Town Hall Lane.

The junction of Highcross Street and Guildhall Lane, with the BBC studios on one side and St Martin's House, built as the Wyggeston Boys' School and later occupied by the Alderman Newton's School, on the other, was close to the centre of the Roman settlement where important routes converged. Folklore suggests that ancient tunnels connect the oldest of the structures in this area.

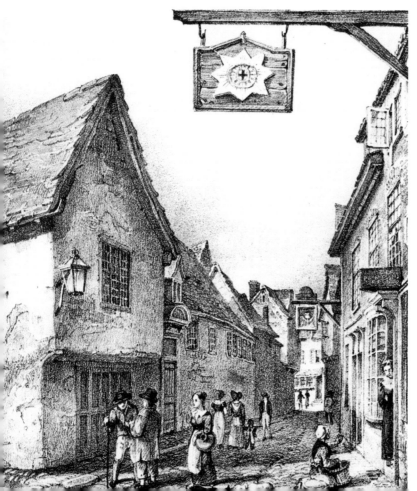

John Flower's etching of Guildhall Lane and the Guildhall.

As with all the lanes and streets in the older part of the city, so many different aspects of life, past and present, combine in Guildhall Lane, with former textile factories in the shadow of the Cathedral Church of St Martin, side-by-side with public houses, shops, cocktail bars, offices and a few private residences. One former factory is now the Nagarjuna Kadampa Buddhist Centre, which serves a range of wholesome lunches and is well patronised every day by workers in nearby offices.

# Granby Halls

Built as recruitment and training halls for the Army, the Granby Halls became a popular entertainment venue accommodating such diverse events as boxing tournaments, rock concerts, amateur radio and Home Life exhibitions, ice skating and basketball. In the 1970s it became part of Leicester City Council's sport and recreation facilities, but investment was lacking and the building was eventually deemed to be out of date and too costly to maintain and renovate.

The building's name is linked to land ownership. In the eighteenth century much land in the town was owned by Lord William Manners, 2nd Duke of Rutland. It passed to the Dysart family through the marriage of his heir, John, who was titled by the family Marquis of Granby, to Louisa, Countess of Dysart. The Earls of Dysart retained ownership until the land was purchased by the Corporation of Leicester in the mid-nineteenth century.

Plans to redevelop the site have been proposed, including high-rise apartment accommodation, but at present the area where the halls stood serves as a car park for the adjacent Welford Road rugby ground.

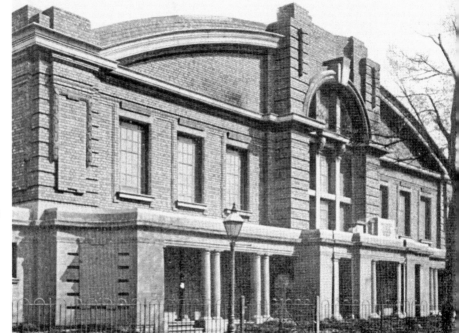

Still missed and much loved, the former multipurpose Granby Halls leisure complex.

# Great Central Railway

The GCR was the last main line constructed in the United Kingdom. It opened in 1899, providing a fast and impressive route from north of Nottingham through Leicester to London Marylebone, with gentle gradients and wide curves, which meant it could operate a timetable that the existing railway companies found difficult to match.

Leicester Central Station closed in 1969. Many remnants of this once great line can still be seen across the city of Leicester as viaducts, foundations of bridges across roads and the river, and in the shell of the old station, which is now home to small local businesses and provides car parking spaces. Overall, the building looks dour and uninviting but is still in good condition, having been built to very high construction standards. It is still possible that this important part of Leicester's transport heritage can be rescued and brought back to life.

Another Great Central Railway operates today on part of the original route. A group of enthusiasts was determined to keep the line alive for the running of main line steam engines. The Great Central Railway (1976) Ltd was formed to raise funds through the sale of shares. Since then, a double-track section has been reopened from Loughborough Central to Rothley and a single track to Leicester North where a new station has been built. Leicestershire is now the only place in the country, and one of the few locations in the world, where main-line steam-hauled trains can still be experienced, passing each other at speed.

The Great Central Railway's new Leicester terminus opened in 2002.

The GCR is Britain's only main-line heritage steam railway.

# H

# The Haymarket Theatre

All the buildings in the entire area between the Haymarket, Belgrave Gate and Humberstone Gate were demolished in the early 1970s to make way for the Haymarket Shopping Centre, which occupies a triangle of land extending outwards from the clock tower. As part of this development, Leicester acquired a new theatre, which achieved national acclaim within a few years.

The theatre opened in 1973 with the official ceremony being presided over by Sir Ralph Richardson. It had been designed by Stephen George and Dick Bryant from Leicester City Council's architect's department, who had also designed the smaller and 'temporary' Phoenix Theatre. The Haymarket was both an attractive and unusual building, and many of its design features were far ahead of its time.

The Haymarket Theatre attracted creative people of imagination and skill. In its first season, theatregoers were able to see *The Recruiting Officer*, the classic comedy play from 1706 by the Irish writer George Farquhar; *Economic Necessity*, a new play in 1973 by John Hopkins and starring Anthony Bate; and the musical *Cabaret*.

Two of the theatre's first production directors were Robin Midgeley and Michael Bogdanov, and for many years Robert Mandell was the musical director, masterminding a string of immensely successful musicals, many of which later moved to London and even to Broadway. When Leicester's new theatre, Curve, opened in 2008, the Haymarket closed and has been silent ever since, but in 2015 a local consortium was formed to

The Leicester Haymarket Theatre.

reopen the building and use it for community art projects. This innovative building, arguably the best element within an otherwise mundane shopping development, brought life, fun and entertainment to local theatregoers and visitors alike.

# Highcross Street

Highcross Street was the medieval spine of the town and connected the North Gate to the South Gate. Where the street crossed the route through the town from the East Gate to the West Bridge (as the River Soar effectively provided a western defensive boundary guarded by the castle), a market grew up and a cross was erected. The last remaining pillar of the old cross, which provided shelter for the traders, stands near to original site on the corner of Jubilee Square.

The street is now divided by the central ring road where the modern façades of the Highcross shopping centre stand. To the south of the junction with High Street, the road becomes the modern St Nicholas Place and then Applegate, which must not be confused with a street of the same name that once existed near to where the Holiday Inn now stands.

Jubilee Square, which lies to the west of St Nicholas Place, was laid out, as the name suggests, to commemorate the Queen's Jubilee. The first visit undertaken by Her Majesty the Queen in 2012, her jubilee year, was to Leicester.

Although recent civic investment has brought life back to Highcross Street, it remains an inconspicuous but fascinating street. It speaks of the richness of its past rather than its role in the present. Why the axis of the town moved away from the High Cross to the East Gate is a complex matter. One early and unproven theory is that outbreaks of the plague in the seventeenth century led visitors to avoid the more congested and crowded area of the town inside the medieval walls, preferring to trade from outside its eastern boundary.

# Holy Bones

This now insignificant little street, serving as a slip road off the central ring road, bears one of the most intriguing road names in Leicester. It lies in the very oldest part of the town where the massive Jewry Wall stands, near to St Nicholas Church and the Roman baths complex.

The name appears to date to the early fifteenth century. Two centuries later, the antiquarian historian Edmund Gibson reported that many bones had been unearthed nearby and that these were the remains of people sacrificed to the Roman god Janus. A temple to Janus was certainly located nearby to where the Holiday Inn now stands.

However, rather than being human remains, the bones that have been found are those of animals such as cows and pigs. The more likely explanation is that this was

Holy Bones, now the location of the Guru Nanak Gudwara.

the site of a shambles, a street where the town's butchers carried out their work. It is certainly close to another ancient market, now vanished, which was held in Redcross Street at the Reed Cross.

The line of Holy Bones changed in Victorian times when the Great Central Railway reached Leicester, cutting through this area with dramatic bridges and viaducts. The original line of Holy Bones can still be seen as the access to the Guru Nanak Sikh Temple.

# Holy Cross Priory

Holy Cross Priory can be found in the leafy shade of New Walk, but not far from the busy shopping area, and was funded by friars who followed the teachings of St Dominic. Holy Cross was established as a priory in 1882. The foundation stone of the present building was laid in 1929 and the choir and transepts were opened in 1931, when the high altar was consecrated. The completed church was consecrated on 14 May 1958.

The Dominican friars reached Leicester in around 1247 and were provided with land between two arms of the River Soar, an area still known today as Blackfriars. The priory was surrendered to the agents of Henry VIII on 10 November 1538.

After the Reformation, the first Dominicans to return to Leicester came from Holy Cross Priory in Bornheim in what was then the Spanish Netherlands, but it was later, in 1794 when escaping from French Revolutionary forces, that the Dominicans sought sanctuary in England, and one of their number, Benedict Caestryck, came to Leicester. A relic of the True Cross, which came from Bornheim, is venerated at Holy Cross in Leicester.

The church faced considerable damage during the Second World War. It was one of the first buildings to be hit when German bombers attacked Leicester soon after 7.30 p.m. on 19 November 1940. It was rebuilt and is now a most impressive and welcoming place.

# Hotel Street

Hotel Street has never had a hotel in it. It is named after the building that stands on the corner, now known as the City Rooms, which, although designed as a hotel, opened as a coffee house and ballroom.

The street is within the Market Place Conservation Area and provides an important pedestrian link for shoppers between the St Martin's precinct and Leicester Market, of which it forms the western boundary. A number of banks built prominent buildings here, which, with the changing fortunes and attitudes of the banking industry, have gradually been converted into bars and restaurants.

One hundred years ago, the street provided many of the services required and expected of the gentlefolk of the town including bootmakers, wine merchants, hairdressers, perfumeries, silversmiths and cheesemakers, but the dominant retail presence became the highly regarded department store owned by Morgan Squire. This was an institution that set the standard for all its competitors in Leicester, and many shop assistants at other stores aspired to work for the company. It was acquired by House of Fraser in 1970 and closed down soon afterwards, but the buildings remain as homes for new individual shops.

Near to the corner of Hotel Street, but located in St Martin's, is the former Parr's Bank, a magnificent yet somewhat disregarded building designed by Samuel Perkin Pick, who was once the principal architect of Everard and Pick of Leicester. It was built at the turn of the nineteenth century for Parrs, which had been founded in Warrington in Lancashire in 1788 by two sugar refiners, Joseph Parr and Thomas Lyon. The bank became a branch of National Westminster Bank when Parrs amalgamated with the London & Westminster Bank in 1918.

*Below left*: The City Rooms, a hotel that never opened, but now a successful banqueting venue.

*Below right*: The *Seamstress*, Leicester's most delightful statue, created by James Butler.

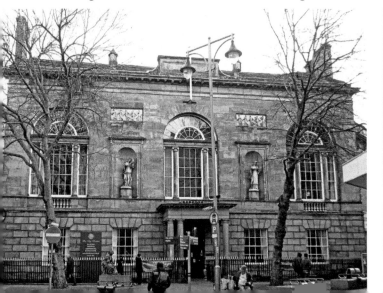
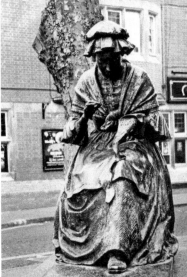

# I

## Il Rondo

For any Leicester resident who was a teenager in the 1960s or 1970s, Prezzo in Silver Street is a venue that will bring back many memories. Today it is a popular Italian restaurant, but two decades ago it was the epicentre of Leicester's music scene and pop culture.

The key to this small club's success was the enterprise of its owner Richard Furness and his contacts in the national music scene. This enabled him to book The Who to play at Il Rondo on the same day they first entered the charts in February 1965. The young people who went to see them on that night paid just 25p for the experience.

Il Rondo also brought jazz to Leicester in the forms of Kenny Ball and Humphrey Lyttleton, and the diversity of musical talent to be found in this small backstreet venue also encompassed blues musician John Lee Hooker, soul singer Long John Baldry and rock stars Steve Marriott, Rod Stewart and Julie Driscoll.

# J

# Sir Alec Jeffreys

Born in Oxford and educated in Luton and Merton College, Oxford, Sir Alec Jeffreys' association with Leicester began in 1977 when he was appointed to an academic post at the University of Leicester. During ground-breaking research, on Monday 10 September 1984 at 9.05 a.m., Jeffreys saw the potential of DNA fingerprinting, having noticed similarities and differences in DNA samples taken from different members of a colleague's family.

The first use of DNA fingerprinting in a murder case was with the Narborough Murders, when Colin Pitchfork was convicted for the murder of two schoolgirls (in 1983 and 1986) in the Leicestershire village of Narborough. The male population of the area were asked to provide a DNA sample to eliminate them from the investigation. Pitchfork was caught after staff at the bakery where he worked overheard him boasting that he had succeeded in avoiding giving a DNA sample by paying for a friend to take his place.

The science and techniques that Sir Alec established are used worldwide in many areas of research and science. They were used to assist in the identification of the remains of Richard III in 2012. Sir Alec is now professor of genetics at Leicester. He became a Freeman of the City of Leicester in 1992 and was knighted for his services to science and technology in 1994.

# Jewry Wall

The purpose and nature of Leicester's oldest standing structure, and the largest Roman building outside London, was not fully understood until excavations by the pioneering archaeologist Kathleen Kenyon took place between 1936 and 1939. It was taken into state care in 1920 but had been largely disregarded until the nearby archaeological remains were discovered when a factory on the site was demolished.

Kenyon first believed that the site was part of the Roman forum. She later changed her opinion, suggesting that the earlier forum had been rebuilt as baths. Not until much later archaeological research, between 1961 and 1972, was the forum site

confirmed as being to the east near to the modern Jubilee Square. The Jewry Wall was then seen as the wall of a gymnasium, which would have been part of the baths complex, but this is not accepted by all.

The name of the wall is also a mystery. It was known by its present name as early as the seventeenth century. One theory is that it relates to Leicester's medieval Jewish community, who was expelled from the town in 1231 by Simon de Montfort. Another suggestion is that it is connected to the *jurats* of early medieval Leicester who formed the senior 'cabinet' of the Corporation, and met in the town churchyard, possibly that of St Nicholas' Church. The word is from the same root as juror, being someone who has taken an oath to perform a certain duty of judgment. The antiquarian William Stukeley used this name and accepted this definition for his map of Leicester, published in 1772.

It is now generally agreed that 'jewry' represents a broader folk belief across Europe that tended to attribute the origin of any mysterious structure to the Jewish people.

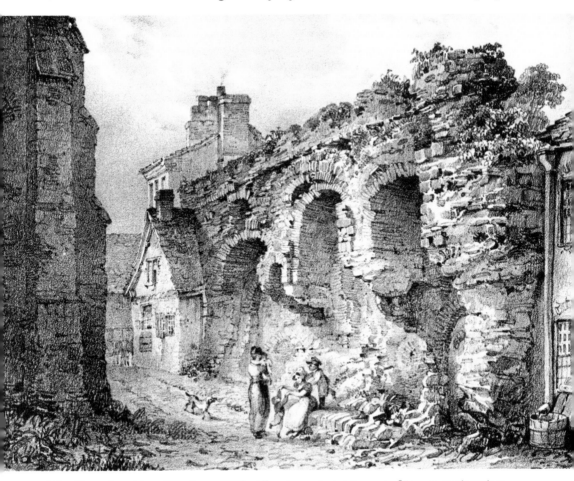

John Flower's etching of the Jewry Wall, still an imposing statement of Roman engineering.

# Jewry Wall Museum and Vaughan College

The concrete structures that looks out across the Roman remains towards the Jewry Wall were built in 1962, designed by Trevor Dannatt as a replacement for the earlier Vaughan College building that was demolished during highway improvements. The college had been founded in 1862 by Revd David Vaughan, vicar of St Martin's Church (now Leicester Cathedral), to provide education for men in the centre of the town. It expanded its work to become a major institution for adult education and self-improvement for both men and women.

It was Alderman Charles Keene, a one-time lord mayor of Leicester and a pro-vice chancellor of the university, who proposed a revolutionary plan of bringing the college together with a new museum dedicated to the analysis of Roman Leicester and incorporating the excavated Roman remains. The building work began in 1959 and took three years to complete. The museum occupies the lower floor, which is below ground level on the same elevation as the remains. It opened on 4 March 1966. The college operated from the floors above the L-shaped building, with impressive panoramic views of the entire site including the Jewry Wall and St Nicholas Church.

In recent years, the University of Leicester transferred the college's classes to its campus south of the city, leaving that part of the building unoccupied. In 2015 it was purchased by Leicester City Council with a view to finding a lasting use for this iconic structure. Extensive refurbishment of the museum was announced by the city mayor at an event marking the building's 50th anniversary in 2016.

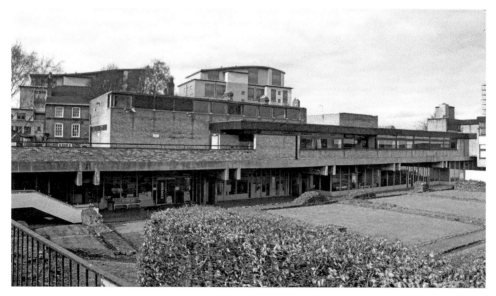

Modernist and brutal in design, the Jewry Wall Museum relates well to its historic environment.

# K

## William Wheeler Kendall

In 1870 William Wheeler Kendall, the son of a farmer from near Market Harborough, travelled to Leicester intent on making his fortune. His business of selling umbrellas began in a barber's shop in Northampton Street. One hundred years later, the company had over 100 High Street stores, and Kendall's umbrellas were sold worldwide. Five were supplied to the 1952 expedition that conquered Everest.

Kendalls moved to a purpose-built factory in Charles Street in 1932, which was designed to provide good working conditions for the staff. The company was a pioneer in staff welfare and one of the first to provide free tea breaks and a staff canteen, as well as staff excursions to Skegness and other resorts.

During the Second World War the company supplied parachutes and mackintoshes for British troops. Afterwards, they expanded into rainwear and used innovative marketing techniques including hiring the model Twiggy and buying the entire front page of a national newspaper on St Swithin's Day.

Kendalls remained a family business until 1977. It was later sold to Hepworths, which, under the leadership of entrepreneur George Davies, converted seventy Kendalls stores to the Next brand, a highly successful business still based in Leicestershire. Davies went on to create his own George brand, which trades through the Asda supermarket chain.

# Robert James Lees

Tracking down Jack the Ripper and acting as Queen Victoria's personal spiritual adviser are two of many remarkable claims attributed to the Leicester psychic who was born in Hinckley in 1849 and died in Leicester in 1931. Lees said that 'psychic events' had been a part of his life since his cradle days.

To escape poverty his family moved to Birmingham, and Lees was apprenticed to a printer. Despite having little formal education, he secured employment with the *Guardian* newspaper in Manchester. He moved to London when the newspaper was considering launching a southern edition.

In Peckham, South London, in 1892 he ran an organisation to support socially disadvantaged people, based on socialist and co-operative principles. In his later years he retired to Leicester and lived in Fosse Road South where his eldest daughter, Eva, cared for him. He appeared at several rallies in the marketplace, and counselled many spiritualists worldwide by corresponding with them. He also published several

A man of dark secrets. Victorian psychic Robert James Lees (1849–1931).

books, which he said had been written by his spiritual guides. Having strong Christian principles, Lees refused to align himself with the formal spiritualist movement, but the Christian churches shunned him because of his controversial beliefs.

# Leicester Castle

Despite its present-day appearance and its seventeenth-century exterior, Leicester's castle was probably built only a few years after the Norman Conquest, which suggests that plans for its construction were drawn up almost as soon as the invaders reached Leicester. The first structure was a wooden motte-and-bailey castle that has survived and is accessible by a footpath. Today it is not easy to appreciate that this fortification, standing on earlier Roman structures, effectively guarded the southern and western approaches to Leicester, making use of the river as a moat.

The Great Hall has one of only three Norman arched ceilings in Britain and dates from 1150. It was built by Robert de Bossu, 2nd Earl of Leicester, and is the oldest aisled and bay divided hall in Europe. John of Gaunt lived here and welcomed a young Richard II, who returned years later as a prisoner, before his deposition by Gaunt's son, Henry IV. The exterior was built in 1695 as a family mansion, and in the nineteenth century the building was converted again to become the assizes.

The nineteenth-century Leicester historian James Thompson, in his book *Leicester Castle* published in 1859, commented that 'it was more than a baronial mansion – it was the Palace of the Midlands during the most splendid period of the Middle Ages'. However, Thompson was writing in an era that tended to romanticise the past. He believed the motte existed much earlier than the Conquest and that the underground building, known as John of Gaunt's cellar, was the castle's dungeon. Such opinions have not withstood the test of modern scholarship.

Leicester Castle, once the Lancastrian seat of power under John of Gaunt.

# Leicester Cathedral

The parish church of St Martin became Leicester's cathedral in 1927, but it has been one of the principal churches in the town for more than 700 years, and the 'civic' church since the sixteenth century.

The appointment in 1927 of Dr Cyril Bardsley as the bishop of Leicester was a significant event in the ecclesiastical history of the town, recreating the bishopric after almost a thousand years. It is said that Cuthwine, Leicester's first bishop, was appointed in 679. The last of these early bishops was Ceobred, who was consecrated between 839 and 840 and died between 869 and 888 when Danish incursions led to the see being transferred to Dorchester-on-Thames in Oxfordshire. The location of the first cathedral in Leicester is not known but it is likely to have been the nearby parish church of St Nicholas.

The Guild of Corpus Christi was founded in 1343 as a social and religious guild attached to St Martin's Church, and the church itself was enlarged by a great south aisle to accommodate a dedicated chapel.

The Vaughan porch on the south side of the church was built in 1897 in memory of Edward Vaughan and his sons, all of whom gave much to the town. Charles, Edward and David followed in their father's footsteps to become successive vicars of the church. The family name lives on in Vaughan Way, part of the central ring road.

The reinterment of Richard III in 2015 gave this modest cathedral a prominent place on the world stage, with tourists visiting from great distances. A simple tomb marks the king's final resting place after much turmoil – during his lifetime and after his remains were discovered – and is already a place of modern pilgrimage.

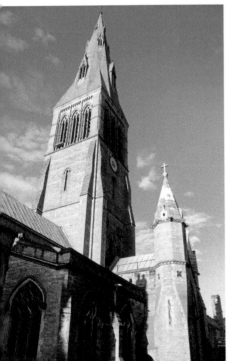

Dedicated to St Martin, Leicester Cathedral has been the seat of the bishops of Leicester since 1927.

# Leicester Market

Behind the façade of the shops along Gallowtree Gate, and connected by the 'jitties' or alleys between the buildings, Leicester Market is still the vibrant heart of Leicester's retail experience after many centuries of trading. The jitties mark points of access breached in the old town walls, when merchants would follow the turnpike from Market Harborough to arrive in Gallowtree Gate wishing to trade their wares on the market inside.

Leicester has had numerous markets in its long history, and today's street names provide some clues to their locations. Horsefair Street is self-explanatory, and the High Cross was, unsurprisingly, another point at which trading and bartering took place. There was another market in Redcross Street, formerly the 'Reed Cross', but that has now been lost in redevelopment. The High Street was once Swinesmarket.

Surviving wars, winds, redevelopment and numerous other threats to its existence, Leicester Market has been trading for more than 700 years. The colourful and diverse stalls of today tell a fascinating history. The first known royal grant dates to 1229, although the traders mark their anniversaries from a document of 1298. Far more recently, the present market roof was opened by veteran entertainer Bruce Forsyth in 1992, and a permanent café was added in 2002.

The latest chapter in its history began with the demolition of the former indoor market in 2014, to be replaced by a modern structure that still respects the heritage of the area.

# The Leicester Pageant

Abbey Park was the stage for the Pageant of Leicester, which took place across ten days in June 1932 and was one of the most remarkable events in the modern history of the city. This massive public and civic event saw the bringing together of men, women, young people and children from all walks of life and professions, from schools, colleges and businesses in a celebration of the history, heritage and commercial potential of Leicester. It was the first event of its kind in the city's history and it has never been surpassed. Visitors to Abbey Park today can see the arena and backdrop to the event that was staged over eighty years ago, and marvel at the colossal scale of the undertaking in an age before the modern benefits of IT and mobile communications.

It took place at a time of economic depression for the entire country, and was opened on 16 June 1932 by the Viscountess Snowden and all the city's Members of Parliament. Each day followed a different theme that embraced the Empire, civic pride, the county, industry and drama. The final day was devoted to children. The many hundreds of colourful costumes were designed and created by staff and students of the Leicester College of Art, rehearsals took place for months beforehand in halls and schools across the city, and by the time of the finale, nearly 120,000 people had paid to attend.

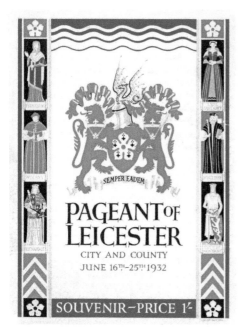
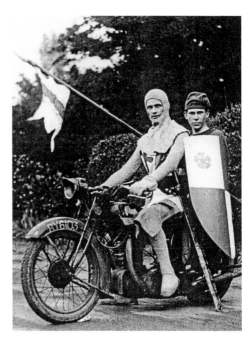

*Above left*: The front page of the official 1936 Leicester Pageant Programme, a major event in Leicester's recent past.

*Above right*: The Leicester Pageant was a diverse event involving many people in many different roles!

# Leicester Royal Infirmary

The Leicester Royal Infirmary has been caring for patients since 1771 and is still on the same land, south of the Newarke, which was acquired for the purpose in 1768.

The founder was Revd William Watts (1725–86). He was descended from John Watts, the owner of Danet's Hall, an ancient manor on the western side of the River Soar where a settlement developed either side of the line of the Fosse Way, recorded in documents as early as the thirteenth century.

Watts gained his medical qualification from King's College in Aberdeen and became an honorary physician to the newly opened County Infirmary in Northampton. Watts believed that Leicester needed a similar hospital, but first he resigned his post and in 1762 took holy orders, becoming the curate-in-charge of St Giles Parish Church in Medbourne in Leicestershire.

It was here that he began raising funds for a Leicester hospital, using his considerable powers of persuasion, writing letters to local newspapers, and encouraging the wealthier citizens of the town to contribute to a fund as subscribers. In a short span of time, Watts purchased the land he required and commissioned Benjamin Wyatt of Staffordshire to build an infirmary, initially

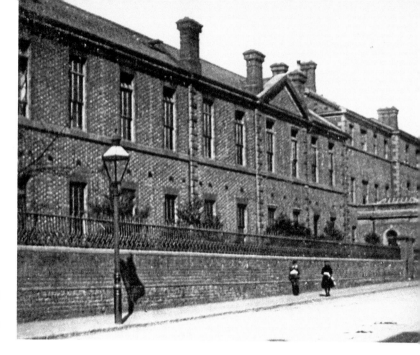

The original Leicester Infirmary, now surrounded by many additions and extensions.

providing accommodation for forty beds. He moved into the family home at Danet's Hill to be near his work.

The hospital soon expanded to provide an 'asylum for lunatics' in 1782 and numerous other wings and wards. In 1912 it gained its royal status to become the Leicester Royal Infirmary. Today it is Leicestershire's principal hospital.

# Leicester Tigers and the Welford Road Ground

Leicester Tigers' famous ground opened in 1892. The first stands accommodated just 1,100 spectators, but were adequate, given rugby's limited appeal and status at the time. A clubhouse was added in 1904 on the Aylestone Road side of the ground, and this gave rise to the anomaly of having a ground called Welford Road with a postal address of Aylestone Road.

The club was formed at a meeting in the George Hotel in Leicester in August 1880, and was a merger of three teams: Leicester Alert, Leicester Amateur FC and Leicester Societies AFC. It was not until more than five years later that the club acquired the Tigers nickname, which may have been taken from the Royal Leicestershire Regiment that received the title after having served in India and used an emblem of a tiger on their hats.

Seating and facilities at Welford Road have been extended on many occasions, most notably in 1995 when the Goldsmith's Stand was built. In 2016, a further stand was constructed adjacent to Aylestone Road at the cost of almost £7 million to accommodate 2,917 spectators and 190 executive seats, bringing the capacity of the ground up to

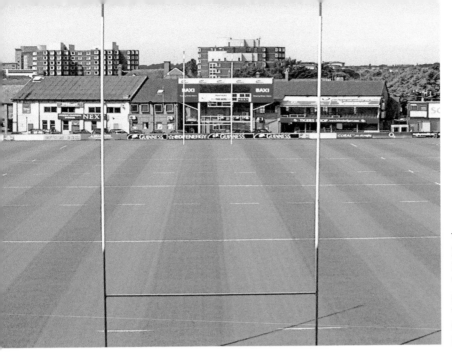

Welford Road, the Leicester Tigers ground. The view towards Oxford Street.

26,000. Before this era of development commenced, serious discussions were held with Leicester City Football Club about a joint venture that would have seen both clubs sharing the same ground on the site of the then Walker's Stadium, but agreement could not be reached on which club would have priority in the use of the pitch.

# University of Leicester

Forming a dramatic backdrop to Victoria Park, especially at sunset, are the three tower blocks of the University of Leicester's campus: the Attenborough Building, the Charles Wilson Building and the Stirling and Gowan Engineering Building. Architecturally, they are distinctive and different, each representing a specific style of modern architecture.

The University of Leicester was founded as the Leicestershire and Rutland University College in 1921. Thomas Fielding Johnson, a local textile manufacturer and philanthropist, donated the land to create a 'living memorial' for those who lost their lives in the First World War. This is reflected in the university's motto '*Ut Vitam Habeant*', meaning 'so that they may have life'.

Students were first admitted in 1921. It became University College Leicester six years later, with students being awarded external degrees from the University of London. The central building, now known as the Fielding Johnson Building and housing the university's administration offices and Faculty of Law, dates from 1837 and was constructed as the Leicestershire and Rutland Lunatic Asylum. In 1957 the college was granted its royal charter and the status of a university with the right to award its own degrees. A more light-hearted but equally significant achievement in its early days as a university is that it won the first ever series of *University Challenge* in 1963.

Viewed across Victoria Park, the three towers that mark the University of Leicester campus.

# The Lewis's Tower

Prominent on the skyline of Humberstone Gate, near to the junction with the clock tower and Gallowtree Gate, is the famous Lewis's Tower. It is all that remains of the former Lewis's department store. Not to be confused with the modern John Lewis Partnership, this chain of stores was funded by David Lewis in Liverpool in 1856. The original store sold men's and boy's clothing, expanding to sell women's clothing in 1864. The Lewis's Group continue to grow and further stores opened across the country with branches in Manchester, Birmingham, Sheffield and Leicester. The Leicester store was built in 1936. The company went into administration in 1991 but continued trading in Leicester under a management buyout for a further two years. Soon after closure, the entire building except for the iconic tower was demolished to make way for the modern shops that are to be seen today.

Still in keeping with its modern surroundings, the tower of the former Lewis's store.

The tower was designed as a receiving point for radio transmissions from the 'mother' store in Liverpool. Each day before the stores opened to the public the management in Liverpool would speak live to the shop assistants on shop floors across the country.

# The Liberty Statue

Leicester's own version of the Statue of Liberty was sculpted in the city by Joseph Morcom, who worked from premises in the Newarke. Morcom also created the statue of Cardinal Wolsey in Abbey Park. It was commissioned by shoe manufacturers Lennards following a visit to New York by their directors in the 1920s.

The statue, which weighs 9 tons and is 17 feet high, once stood on the roof of the Liberty Shoe factory until the building was demolished in 1983. It was then placed in storage before becoming the centrepiece of a new road scheme near Western Boulevard, just a few yards from its original location. Due to weathering over seventy years, some restoration was necessary. Craftsmen also modified the statue's crown, face and right arm, changes that were criticised following the unveiling.

The statue has been a popular landmark for Leicester City fans attending matches at both Filbert Street and the King Power Stadium, and was adorned with blue and white scarves to celebrate Leicester City's Premier League achievements in 2015/16.

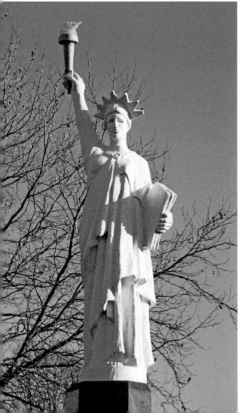

Leicester's Liberty Statue, the work of Leicester's Joseph Morcom.

# Gary Lineker

Undoubtedly a footballer of world renown, not least because of his unblemished career record of never being presented with a yellow or red card. His father, grandfather and great-grandfather were greengrocers, and the family still trades on Leicester's market.

He attended Caldecote Road School and Leicester Boys' Grammar School on Downing Drive in the city. As a lad, Lineker excelled in cricket as well as football. From the age of eleven he captained the Leicestershire Schools cricket team and believed he had more chance of succeeding at cricket than football

When he left school with four O levels, one teacher commented that he 'concentrates too much on football' and that he would 'never make a living at that'. Shortly afterwards he joined the youth academy at Leicester City.

His career is legendary. Lineker retired from international football with eighty caps and forty-eight goals. He transferred, effortlessly, to a new career as a television sports commentator, a role that has also offered him work as a newspaper columnist and television presenter in European and American markets.

His popularity has allowed him, since 1995, to feature in a light-hearted series of commercials for the locally based Walkers crisps. Walkers temporarily named their salt and vinegar crisps after Lineker in the late 1990s as 'Salt-n-Lineker'.

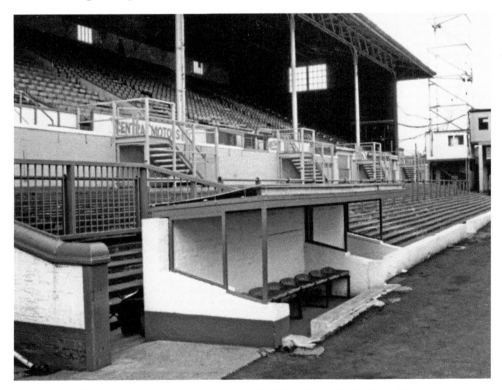

Gary Lineker's former place of work – Leicester's Filbert Street football stadium.

# Market Street

It was in 1815 that Market Street was laid out. A building that may date from the time is Nos 23–25 Market Street, where there is evidence of an original lime-ash floor on the second storey. Perhaps because of its proximity to the houses of the wealthier classes of the town in nearby streets such as Millstone Lane, the shopping character of Market Street was regarded by local people as somewhat 'upmarket'. It was the principal location for milliners and hatters. Even in 1933 it was being described as an 'aristocratic shopping centre'. Today it is a pedestrianised shopping area with a pleasant mix of independent shops, boutiques and cafés.

Leicester's first electricity showroom was opened in Market Street in April 1923. The stated object of the premises was 'educating domestic consumers in the use of heaters and cookers, and other appliances, as well as in lighting'. As part of the promotion

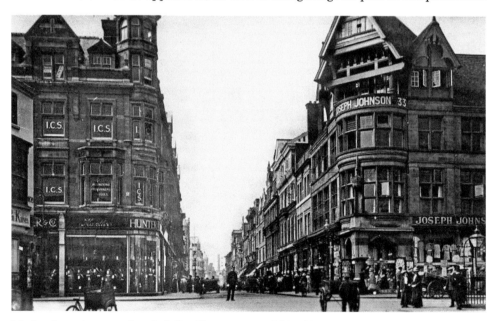

Market Street in around 1916, defined by two powerful buildings by Isaac Barradale.

of electricity as the modern form of power, a scheme for hiring 'apparatus' was introduced. There followed a boom in consumption. New applications for connection to the power supply reached 3,000 households a year by 1926, with a total of over 20,000 consumers being connected.

# Joseph Merrick

It was the film starring the late Sir John Hurt, from the book by Michael Howell and Peter Ford published in 1980, that gave Joseph Merrick lasting fame as the 'Elephant Man'. However, although perceived as a sad story of the harsh and inhumane treatment of a young man with gross disfigurement, Merrick is regarded today as a person of great dignity and inner peace.

He was born at No. 50 Lee Street, near to where the Lee Circle car park now stands. His family was poor, but his mother ensured that her son received elementary education. When she died, Joseph was still a boy, and he lost the person who loved him the most. His father sent him out as a street vendor, but his disfigurement frightened people. Thrown out of the family home, he chose to enter the Leicester Workhouse. Remarkably, he also decided when to leave the workhouse by negotiating an arrangement with the owner of the Gladstone Vaults, the theatre near to where he had lived. Thus began his career on stage.

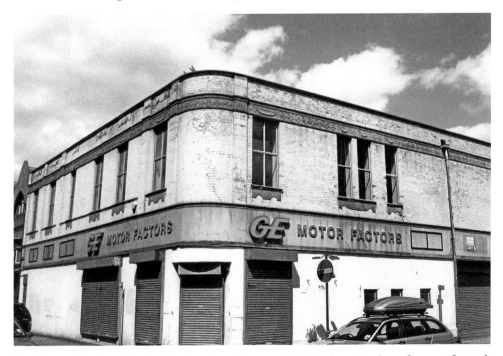

The former Gladstone Vaults Theatre where the so-called 'Elephant Man' may have performed.

The interest of medical men in Lees' disabilities was caring as well as academic and objective. At the London Hospital, where he lived until his death at the age of twenty-seven, the surgeon Frederick Treves became his close friend.

A plaque in his name on the wall of Moat Community College marks the site of the former Leicester Workhouse, and civic leaders in Leicester are still debating how best to recognise and celebrate this brave, talented and personable young man.

# Edith Murphy

The Edith Murphy Building stands on Southgate overlooking the Newarke Gateway and Magazine Square, and commemorates one of Leicester's more recent benefactors.

Edith Murphy inherited the proceeds of the sale of the Charles Street Group, a transport, property and industrial empire owned by her late husband, Hughie Murphy. The couple had no children, and Edith lived alone after her husband's death, so she chose to use her wealth to support good causes. This included ground-breaking research at De Montfort University into the treatment of diabetes to which she donated over £410,000. Edith also supported the Breast-screening Unit at Glenfield Hospital and the RSPCA – she had a pet dog called Snowy.

Edith died in October 2005. Edith Murphy House was known previously as Bosworth House and cost £8 million to refurbish and fit out as the university's Faculty of Health and Life Sciences with accommodation for the School of Nursing and Midwifery. It also marked the completion of the longer-term project of bringing all the university's teaching facilities together in the Newarke.

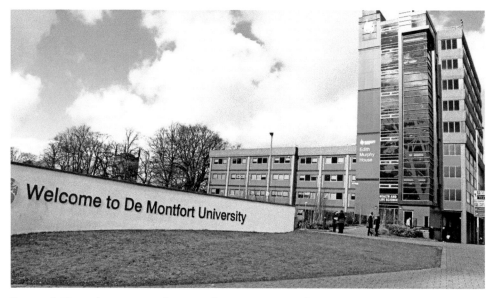

Bosworth House is now part of De Montfort University and renamed Edith Murphy House.

# N

## Parminder Kaur Nagra

One of the first members of the Leicester Asian community to achieve international stardom, Parminder Kaur Nagra was born in Leicester, the eldest child of Sukha and Nashuter Nagra, Sikh factory workers who came to England from the Punjab region of India in the 1960s.

Parminder went to Northfield House Primary School and Soar Valley College, where she played viola in the youth orchestra and also appeared in her first theatrical productions.

Soon after her A levels and leaving school, and while working front of house at the Haymarket Theatre, her former drama instructor invited her to join Hathi Productions, a Leicester-based Asian youth theatre group. She agreed and was cast as a chorus member in the 1994 musical *Nimai* staged at the Haymarket. One week into rehearsals, she replaced the lead actress.

Her international television and film career has included the role of Jess in *Bend it like Beckham* (2002), Dr Neel Rasgotra in the American television medical series *ER*, and Dr Lucy Banerjee in Fox TV's *Alcatraz*.

## Narborough Road South

This important road takes its name from the village of Narborough, which is situated 7 miles to the south-west of Leicester. The word is from Old English 'north burh' or 'north stronghold', as in a fortified house. This is the route of the Roman Fosse Way (Latin *fossa* meaning 'ditch'), which ran from Exeter to Lincoln and once defined the northern border of Roman occupation on which the garrison of Ratae Corieltauvorum (Leicester) was built. It may be that the prefix 'north' refers to the crossroads at Roman Vedonis, some miles further south where the Fosse Way and Watling Street meet, which could indicate that Narborough began as 'one man's fortified house north of that important crossroad'. The line of the Fosse Way runs through the middle of the village along the modern Coventry Road.

When the M1 motorway was constructed, the Narborough Road became a busy traffic route, which led to traffic congestion where it entered Leicester along the

narrow Braunstone Gate and across the river. Consequently, the road was extended to the next river crossing at West Bridge where traffic now joins the central ring.

In 2016 researchers at the London School of Economics cited the section of the Narborough Road within the city as the most diverse road in England. It is known locally as the street where anything can be bought. Owning or operating more than 200 retail establishments, the shopkeepers and their families come from no less than twenty-three different countries and four continents.

# Newarke Houses

Housing Leicester's Museum of Social History, Skeffington House and Wygston's Chantry House now look out across Magazine Square to De Montfort University's buildings from two different eras, the Hawthorn Building and the Hugh Aston Building.

The Chantry House is perhaps the most notable building in the Newarke. Construction began in 1511 to provide accommodation for the chantry priests who were paid by William Wyggeston to say prayers in the collegiate church of St Mary

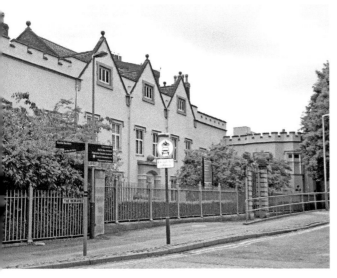

Skeffington House, part of the Newarke Houses Museum.

The former Wyggeston's Chantry House, now part of the Newarke Houses Museum.

of the Annunciation in Newarke. It was extended in the centuries following the Reformation and finally acquired by a private trust in 1912. The trust also purchased the neighbouring Skeffington House, which dates from around the end of the sixteenth century. The Chantry House was badly damaged during the Second World War but was restored between 1953 and 1956. Both buildings were later acquired by the Leicester Corporation for use as a museum.

Surprisingly, although the gardens evoke an air of ancient tranquillity, in the nineteenth and early twentieth century a large corn mill operated here, which dominated the skyline, rising to a height of four storeys. This was also where stonemason and sculptor Joseph Herbert Morcom worked, who created the statues of Cardinal Wolsey in Abbey Park and John Biggs in Welford Place, as well as the Liberty Statue near the Upperton Road bridge. The Elgood Iron Foundry, which manufactured the London Road railway station gates, was also in this area. Two of the Elgood sons, George and Thomas, became successful artists, and one of Thomas's surviving watercolours is of the Newarke with a view towards Skeffington House.

# Newfoundpool

Outside the old boundaries of Leicester to the south lies the densely populated suburb of Newfoundpool. Its name originated in a grand plan by the man who purchased the land in around 1830, a market gardener called Isaac Harrison. His scheme was to make use of the natural springs in the area to create a spa providing hydrotherapy and a bathing establishment. However, the venture failed within a matter of a few years.

The purpose-built baths were converted into a residence and renamed Newfoundpool House, in which several generations of the Harrison family lived. In 1885 the building on Fosse Road North was sold by the family and became the Empire Hotel. The Harrison family continued in the business for which they were more accustomed and successful, namely as seedsmen. For many decades their seeds were sold to gardeners across the country, packaged under more well-known brand names.

Local builder Orson Wright then acquired Newfoundpool and from 1885 began laying out roads across the land, selling off portions as building plots. These were quickly developed with houses in a variety of sizes and styles. Newfoundpool remained outside the borough of Leicester until 1891, Fosse Road being the boundary.

The area's historical connection with the Harrison family is commemorated by the initial letters of the street names between Pool Road and Beatrice Road, which as an acrostic spell the name Harrison. These are Hawthorn, Alma, Rowan, Ruby, Ivanhoe, Sylvan, Oban and Newport streets. Pool Street is reminiscent of the original spa waters. Beatrice, as in Beatrice Road, was Harrison's daughter.

The spire of Leicester Cathedral dominating the view along New Street.

# New Street

At the end of the first decade of the eighteenth century, this became the first route to be cut through the ancient and hallowed land of the Greyfriars. Hence it was a 'new' development, which must have signified the beginning of a new era as the imprint on Leicester of the old religious orders began to fade.

Running parallel to the street called Greyfriars, it was laid out in 1711 when the friary site was still discernible and in the ownership of the Herrick family. Yet it was designed with a 'kink' in it, which means that the spire of Leicester Cathedral only comes into view, looking north, at a certain point in the street. There seems to be no available explanation for the decision to lay out the street in this way. Like Loseby Lane, the street has retained much of its original architecture and atmosphere. Opposite No. 11 New Street, with its stately Corinthian-style columns, stood, until recent years, the last surviving pump in the town.

For several hundred years, New Street has been the 'legal quarter' of the town, where many of Leicester's oldest and most well-known solicitors and legal practices have occupied rooms, although the street has also been the location of offices for trades unions and other organisations.

# New Walk

There are very few major cities that have a public footpath that was pedestrianised as early as 1785 and has remained free of traffic to the present day. New Walk links Victoria Park on the outskirts of the city centre with the heart of Leicester, connecting

businesses, shops and the University of Leicester, and providing a place of exercise, communication and tranquillity.

It was originally called Queen's Walk in honour of Queen Charlotte, the wife of George III, and was laid out along the line of the Roman Via Devana or Gartree Road, which connected Leicester with the village of Medbourne in south Leicestershire, and probably continued on to Godmanchester (Roman Durovigutum), now in Cambridgeshire, and thence to Colchester. At first, it traversed open fields, part of the great South Field of the town. It later became the parish boundary between St Mary's and St Margaret's and provided a route to the new racecourse, which was opened on Victoria Park in 1806. The eastern side of New Walk was then built up, giving the houses an open view over countryside. The other side of the path was developed later when the Corporation acquired rights over the land.

Three areas of green open space were incorporated into this era of development, these being Museum Square and De Montfort Square, and the later Oval, which was originally called Albert Grove in memory of Prince Albert.

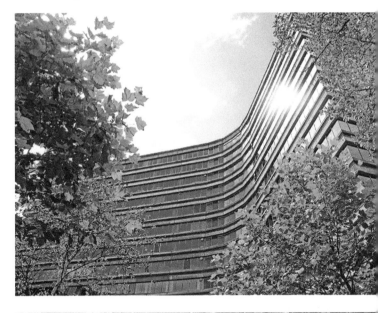

The New Walk Centre, demolished by controlled explosions in 2015.

New Walk, a charming place to walk and socialise since the 1700s.

# O'Neills Public House

A charming tradition is maintained on the Feast of St John the Baptist at O'Neills Irish pub in Loseby Lane when the lord mayor of Leicester and members of the Guild of Freemen of the City of Leicester collect a Damask rose as the annual peppercorn rent.

The ceremony dates to medieval times, the red rose being the emblem of the House of Lancaster. The pub stands near a garden or parcel of land that was once owned by the Honour of Lancaster. It is said that a hostel belonging to the College of St Mary of the Annunciation in the Newarke stood on this site. The church within the college was built as a mausoleum for members of the House of Lancaster, hence the choice of a deep-red rose. After the Reformation this land was purchased from the Duchy of Lancaster by James Teale, a local shoemaker, and his wife Elizabeth for the sum of £2 on condition that he also paid a peppercorn ground rent amounting to 4d and a deep-red Damask rose on the 24 June each year, the Feast Day of St John the Baptist.

By 1729 a public house had been built, on the site that is listed in the Records of the Borough of Leicester as the Red Cow, with Samuel Coates as the landlord. In 1771 the payment was recorded as having been made by 'the heirs of Executors of Samuel Coates for a house later called the Star and Ball and now the Crown and Thistle, late the land of Jackson in the occupation of Alexander Forrester'.

The tradition continued until the end of the early years of the twentieth century when the rent was collected by the city treasurer. The tradition then fell into abeyance until it was revived by Councillor Colin Hall during his term of office as lord mayor in 2010.

# Orton Square

The public open space in front of Curve Theatre in Leicester was named Orton Square by Her Majesty the Queen as a tribute to one of Leicester's more colourful and notorious artistic sons, the playwright Joe Orton. Orton was born and grew up on the city's Saffron Lane estate. The naming was attended by members of Orton's family including his sister Leonie Orton-Barnett.

Joe Orton was born in 1933 and joined several local drama societies before gaining a place at RADA in 1950. He began to write plays in the early 1960s and in 1963 the BBC paid £65 for his radio play *The Ruffian on the Stair.*

On 9 August 1967 Orton was killed by his lover Kenneth Halliwell, who then committed suicide with a drug overdose. Thus ended a short and controversial career.

# Peacock Lane

In the Middle Ages Peacock Lane was called St Francis Lane after the friary. Recent archaeology has now confirmed that the north wall of the Greyfriars church was located close to and parallel with this lane. Its later name refers to an area of land that was known as the Peacock, which existed to the west of the present lane in a network of little streets demolished when the central ring road, St Nicholas Circle and the Holiday Inn were constructed in the 1970s.

Since the discovery of the remains of Richard III, this street has become the focal point for visitors and Leicester residents alike who wish to learn more about the Greyfriars. The graveyard of Leicester Cathedral stands on one side, and the King

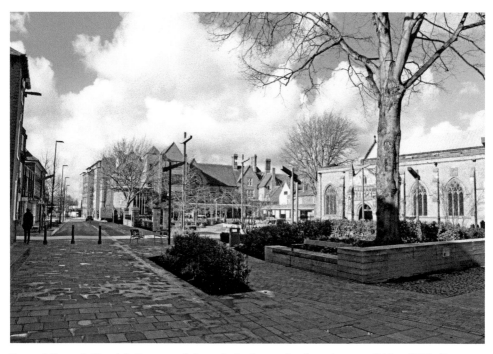

Peacock Lane, St Martin's Centre and the cathedral – new landscaping post-Richard III's discovery.

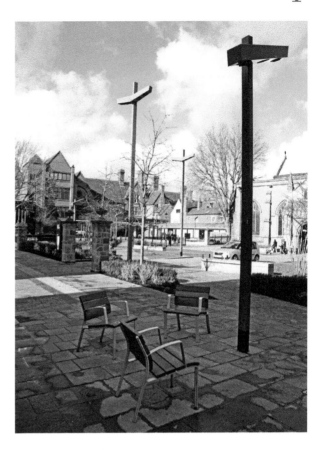

The cathedral precincts near Peacock Lane.

Richard III Visitor Centre, built within a converted Victorian school, is situated on the opposite side of the road. The iconic bronze statue of Richard III by James Butler RA, which was donated to Leicester by the Richard III Society in 1980, was removed from its original location in Castle Gardens and brought to Peacock Lane in June 2014.

Nearby Cank Street takes its name from the Cank, which was a public well. It was located near to the present No. 33 Cank Street and was where local people would exchange news and gossip. The derivation of the word is fascinating and debatable. In some areas, 'to cank' means to 'gossip or to cackle', but in Leicestershire 'cank' is also the name of a particular form of hard sandstone that is known as 'bur' in other areas.

# Phoenix Digital Media Centre

Formerly known as Phoenix Square, the Phoenix Digital Media Centre has a history that reaches back to Leicester's Victorian theatres. After the Second World War, Leicester's theatres struggled to become re-established, and by the end of the 1950s, all, including the Theatre Royal, had closed, leaving the city without any venue for professional theatre performances.

Leicester's city architects designed a temporary and innovative solution in the former Phoenix Theatre, which was constructed within a redundant industrial building in Newarke Street on a limited budget and timescale. It was intended that the Phoenix should be active only until the planned Haymarket Theatre opened, but such was the spirit of innovation of the resident company, this small venue continued to work alongside the new facility for many years, by which time it was exploring new approaches to art in performance including digital media. This was finally transferred to the Cultural Quarter, hence the original name of this new centre. It is also satisfying to note that the old Phoenix is still open and alive, and is now being run by Leicester College.

The Digital Media Centre includes a cinema, café-bar and gallery, as well as a fully equipped video studio. There are also small business units for rent with shared office facilities. Together, the centre can provide a broad introduction to the latest technologies as they relate to art, film and culture. The project cost £21.5 million and was completed in autumn 2009.

# Pocklington's Walk

The Gild of the Freemen of the City of Leicester was formed in 1975, but the history of these men (and now women) dates back to the early years of the twelfth century when Robert de Beaumont, Count of Meulan, son of Agnes de Montfort and a forerunner of the first Earl of Leicester, granted a charter to the merchants of the town. The charter reaffirmed rights that had been granted previously during the reign of William the Conqueror, and suggests that the history of Leicester's Freemen dates right back to the Norman Conquest.

Pocklington's Walk is named after one of these Freemen, Alderman John Pocklington, who was mayor of Leicester in the eighteenth century. Curiously, Pocklington was dismissed from the Corporation in 1766 on grounds of 'insolvency' but became mayor just twelve years later. Pocklington's Walk is so named because it was once John Pocklington's garden, where he and his family would take the air, apparently walking along a straight section of path which is now the line of the road.

Leicester Magistrates' Court is now located in Pocklington's Walk, which has prompted a number of solicitors and other legal firms to obtain premises nearby. One such business occupies the former impressive offices of the Leicester Permanent Building Society. The building dates to 1852 when the Leicester Permanent Benefit Society was formed. It merged with the Leicester Temperance and General in 1974, then changed its name to become the Leicester Building Society and finally merged with the Alliance in 1985 to become the Alliance & Leicester. In January 2009 the word 'Leicester' disappeared forever when it was acquired by Santander.

# Q

# Queen's Building,
# De Montfort University

Completed in 1993, the Queen's Building in Mill Lane is one of several modern structures built by De Montfort University on its Newarke campus, and was the first major building project for the new university after gaining university status in the previous year. It was opened by Her Majesty the Queen. The structure has won numerous prizes including the 1995 Green Building of the Year Award.

Designed by Short Ford Associates, the building meets very high standards of sustainability. It is naturally ventilated and uses natural light, innovations that have dramatically reduced energy consumption and costs to almost half that of a conventional building.

The building is clad in red brick, a traditional building material in Leicester, but its ventilation towers and quirky detail has given Queen's the look of a fairy tale castle. It has nine ground-floor classrooms leading off a large concourse area. The largest classroom can accommodate up to seventy people. There are also two large lecture theatres on the first floor, seating up to 148 people. It is home to the university's Departments of Engineering and Manufacture.

One further quirky fact about Queen's is that, allegedly, many keys are required to lock and unlock the various rooms, a consequence of which is that the property staff need a very large and heavy key ring.

De Montfort University's
Queen's Building.

# The Raw Dykes

This Roman structure remains a mystery. It appears to have been an aqueduct, although it has also been considered to be a canal. The earthworks certainly represent a rare surviving example of Roman water management. In the lord mayor's accounts of the borough of Leicester of 1322, they are referred to as the Rowedick. Archaeologist Kathleen Kenyon, who excavated the Roman baths site in Leicester, noted that the Raw Dykes were lower than the level of the baths in the town, suggesting that the Roman engineers had misjudged the gradients. However, the view of Roman archaeologist John Wacher was that the Romans were skilled engineers and would not have made such an error, proposing that some form of pumping system once linked the aqueduct to the baths, perhaps operated by slaves.

Excavations in 1938 unearthed pottery that confirmed a construction date in the late first century or immediately afterwards. A cross section of the earthwork revealed a broad waterway with a narrower second channel in the centre, which was possibly a design feature to increase the speed of the water flow. A further theory, which has yet to be considered, is that this was part of a canal brought goods into the centre of the Roman town, and that the nearby Knighton Brook is associated with it. However, the River Soar is close to where the Roman engineers needed to deliver a water supply,

The Roman Raw Dykes.

and it would seem more logical for them to have re-engineered the river rather than create a long aqueduct or canal running alongside it.

The Raw Dykes is a scheduled monument, but a viewing platform with an entrance on the Aylestone Road allows visitors to view the 100 metres of this earthwork that remain.

# The Rechabites

The temperance movement of the nineteenth century was particularly strong in Leicester and saw a drawing together of diverse groups with very different principles and outlooks embracing both religious and political beliefs.

The friendly societies were set up to support working-class people by providing health insurance, death benefits and other financial services, but meetings were most commonly held in public houses. The Independent Order of Rechabites was formed by a group of Methodists in Manchester who believed in abstinence. The order was named after the nomadic Rechab, the father of Jehonadab in the Old Testament, who founded the tribe of Rechab. Local branches were called 'tents', since the biblical Rechabites lived exclusively in tents. Each tent was led by a high chief ruler, assisted by a high deputy ruler, corresponding secretary, sick and tent stewards and inside and outside guardians.

A new member had to swear that he and his family would not drink any alcoholic beverages, and sign a document known as 'the Pledge'.

A Rechabite chapel was built in Dover Street in Leicester. The upper floor was taken over by the Leicester Drama Society in 1922, and the society purchased the entire building in 1923. Today, it is the thriving Little Theatre. Members of the Leicester Rechabites lie buried in the ground behind the theatre.

# Richard III

The body of the slain king was brought back to Leicester after the Battle of Bosworth in August 1485, and lay in state for three days in the collegiate church of St Mary of the Annunciation in the Newarke before being handed to the Grey Friars for burial.

Later, various stories about the fate of the king's remains could be heard on the streets of Leicester. In recent times, the debate centred on whether Richard was still lied buried somewhere in the Greyfriars area or if his remains had been unceremoniously dumped in the River Soar. It has to be said that there were many local people who believed the former, but were convinced that he was lost forever.

As to be expected, the archaeologists approached their work with professional objectivity. Their mission was to gain a better understanding of the Grey Friars, not to search for a dead king, but no other English monarch of the past has stirred the

emotions as Richard has, and from the start of the dig in August 2012, the project attracted worldwide interest. From the discovery of a skeleton showing evidence of battle scars and a deformed spine, it took six long months before Dr Richard Buckley, the lead archaeologist for ULAS (the University of Leicester Archaeological Services), announced to the world in a dramatic press conference in Leicester's medieval Guildhall that the remains were indeed those of the last English king to die in battle.

It was then that another chapter of debate opened as to where the monarch's remains should be reinterred. Often emotionally charged, and involving religious leaders, politicians, archaeologists, tourism managers and members of the Richard III Society who had been prime movers in initiating the project, the debate was intense and strongly argued on all sides. Finally, Richard was reinterred in Leicester Cathedral, and the ceremony was televised around the world.

There were some who felt that the procession of the remains around Leicestershire, including the site of the battle, was in poor taste; others believed that it was entirely appropriate for a man whose reign was, by all comparisons, controversial. Business leaders point to the fact that Richard III brought an extra £55 million to the city in a single year.

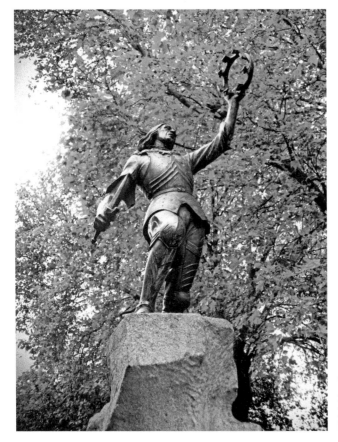

The statue of Richard III at its first location in Castle Park. The sword has since been replaced.

# S

## Saffron Lane

The origins of the name of this road may be found in the use of nearby land as allotments owned by the Freemen of Leicester. Known as Freemen's Common, the land continued to be cultivated until it was sold off in 1965. Possibly, the valuable spice and colouring was cultivated here, or it is a name that lingers from the earlier days of the Freemen, who named some of their allotment paths after flowers.

Soon after the acquisition of the Freemens' lands, the Corporation also purchased 248 acres of land to the south to build a large estate of 1,000 concrete and 500 brick houses. The original intention was to call the new settlement the Park estate, but the name of the lane that connected it to Leicester was the popular residents' choice, hence the name the Saffron Lane estate. Construction began in 1924 on what was to be the first major residential area in Leicester to be developed between the wars. For many, the move to a new house down the Saffron Lane was the first time families had their own toilet and bathroom inside their homes.

The estate is still affectionately known as 'the Saff', but in the early days it was also referred to as 'Candletown' because of the frequent lack of electricity, and also as 'the Conks', describing what seemed like endless rows of homes built of concrete.

The Saff's two most famous residents of past years were both literary figures of distinction – writer Sue Townsend and playwright Joe Orton.

## Sanvey Gate

Before the modern road system that created the St Margaret's Way dual carriageway, Churchgate, from the east gate, continued to the north-west corner of the medieval town where it intersected with Sanvey Gate. St Margaret's Church stands overlooking this junction. Sanvey Gate is immediately outside the former north wall and, until recent years, a noticeable dip in the road marked where the road crossed the former western town ditch. This could be felt by passengers riding on long wheel-based buses.

The earliest reference to this lane dates to 1322 when it was called the Skeyth, a Danish word meaning 'course or racecourse', from which some have suggested that

this was where some form of horse racing took place. An explanation that does not seem to have been considered by historians is that the race referred to a mill race, along which water is channelled in a diversion from a river to power a mill wheel. The route of a former mill race could be described as its 'course'. There is a path nearby that is still known as Old Mill Lane, but the nearest river now seems too far away for this to be a likely explanation. By the fifteenth century the name had changed to Senvey Gate. There seems to be no justification for the suggestion that this meant the road or the way to a holy place, as in St Margaret's Church.

# Shaftesbury Hall

The Shaftesbury Hall in Holy Bones was built as the headquarters of the Mablethorpe Children's Holiday Home Charity. The charity was set up in 1897 by Lady Eliza Rolleston and her husband, Sir John Rolleston of Glen Parva Grange. Originally, it was known as the Leicester Poor Boys Summer Camp.

Lady Rolleston was concerned for the welfare of the many young boys who worked as news vendors on Leicester's streets. She saw that most of the boys had no shoes and were poorly dressed, and when talking to them, she learned that they tended to be the sole breadwinners in their family. Although public health in Leicester had improved considerably since the middle of the nineteenth century, with better sanitation, mandatory vaccinations and flood alleviation projects, a slump in the town's major industries had led to higher unemployment.

Lady Rolleston invited many of these children to her home where she provided nourishment and basic welfare, and went on to establish the Leicester Boys Club to support them. Later, she developed the idea of giving these boys and girls a break from their daily toil by arranging seaside holidays. For many of these children, it was the first time they had seen the sea. The Mablethorpe Children's Holiday Home Charity is still active, with permanent purpose-built accommodation at Mablethorpe, and still operates from Shaftesbury Hall.

# Silver Street

Silver Street is the continuation of Guildhall Lane towards High Street and the clock tower, and like many of the streets in what is called the 'Leicester Lanes' area, it is populated by numerous small shops and boutiques, each with a unique character. It was originally known as the Sheepmarket until that market was moved to the nearby Saturday Market Place in 1506. It was called Silver Street by the end of the sixteenth century, but sheep fairs were still held here occasionally more than two centuries later. The derivation of the name is obscure, although there were certainly silversmiths working in Leicester.

# Spa Place

In Humberstone Gate overlooking the modern roundabout that marks the junction with the central ring road and St George's Way is Spa Place, an impressive terraced building with a fascinating story. Set back from the thoroughfare, the terrace incorporates four expansive brick houses constructed in the eighteenth century soon after it was announced in the local newspapers that a spa or chalybeate spring had been discovered on the site.

In 1893 there was an initial fervour of interest in response to advertisements that promoted the healthy properties of the water. However, Susanna Watts, author of the first-ever guidebook of the town, wrote of this 'range of new and handsome buildings' that 'though furnished by the proprietor with neat marble baths and every convenient appendage for bathing', the water was not found to have enough minerals to be of any benefit.

The project failed, and the building was later sold to a Baptist preacher from Nottingham, Revd Daniel Taylor, who opened a General Baptist College on the premises in 1798. This closed in around 1860 and since then each house has been privately occupied.

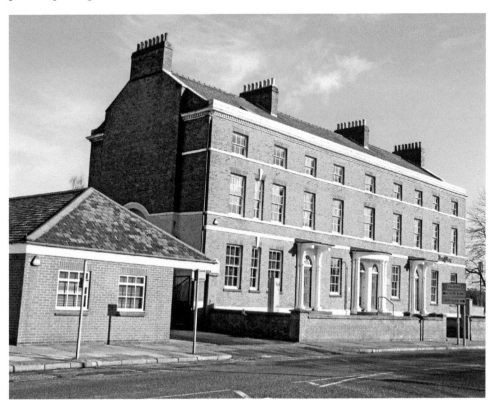

Spa Place, a failed attempt to cash in on spa waters, which left a fine terrace.

# Speedway

Speedway returned to Leicester after the Second World War after an absence of sixteen years. The team was known as the Leicester Hunters. A former rider, Cyril Burton, became the team's manager in 1950, and the team was promoted to Division Two at the end of that season. The track was officially called the Leicester Stadium, known locally and familiarly as the Blackbird Road Stadium, located off Parker Drive. It had been built in 1928, originally as a greyhound stadium. Leicester Hunters under Mike Parker entered a team in the provincial league in 1962 but ended the season near the bottom. Takings at the gate were low and the team moved to Long Eaton. The stadium was closed in 1964.

Speedway returned to Leicester 1968 with the formation of the Leicester Lions under Reg Fearman and Ron Wilson. During the 1970s they competed in the top division of British Speedway, the British League, and in 1977 Vic White took over from Ron Wilson, the pair working together as co-promoters. The last speedway meeting at Blackbird Road was held on 25 October 1983. A stock car grand prix was held in the following year, but then the doors were closed for the final time and after fifty-six years of sporting activity, the stadium was then demolished to make way for a housing estate. However, the Lions returned to Leicester again in 2011 at a new stadium at Beaumont Park.

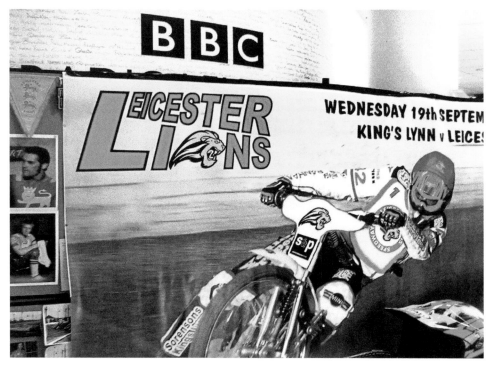

A display at BBC Radio Leicester for the reinvigorated Leicester Lions Speedway team.

St George's Church, now home to Serbian Orthodox
Christians in Leicester's Cultural Quarter.

# St George's Church

The darkened stonework of St George's Church, which was built between 1823 and 1827 by Leicester's William Parsons at a time when the expansion of Leicester led to the construction several new parish churches to serve the increasing population, can be seen from the glass façade of the Curve Theatre in Rutland Street. St George's was the pioneer in this respect, being the first church (as distinct from a Nonconformist place of worship) to be constructed in Leicester since the Reformation. It is in a traditional style known as English Perpendicular, with a tower at the west end.

In 1911 it was badly damaged in a fire, which destroyed the roof and much of its fabric. Colourful photographs of the event were sold as postcards in the town. Nevertheless, it was rebuilt and continued in use until the 1960s. It was then adopted by Serbian Orthodox Christians in 1983, who still worship here. In 2011 the congregation was successful in gaining a Heritage Lottery Fund grant of £106,000 to fund much-needed repairs to the roof. Leicester City Council is also undertaking a major refurbishment of the churchyard and pathways, which are becoming important connections between the Cultural Quarter and the city centre.

# St John's Stone

At one time, the St John's Stone stood in open fields that were part of the land of Leicester Abbey in an area that became known as Johnstone Close. The stone was of sandstone, and it had a great significance for local people. In the early part of the nineteenth century a semicircular amphitheatre had been hewn out of the hillside where people could sit and look at it. At that time, it stood some 7 feet above ground level but by 1875 only around 2 feet of stone was visible.

John Flower's etching of the St John's Stone, now lost from view.

It is claimed that the stone aligned with the Humber Stone on Midsummer's Day, but modern research suggests that a line hewn into the Humber Stone could have formed an alignment, not at midsummer but on May Day – the Feast of Beltane.

Many legends are linked to the stone, including that it was often frequented by fairies who would dance around it at sundown. A custom that survived until the nineteenth century involved an annual visit to the stone on St John's Day (24 June) where a festival was held, which had vestiges of old fire or sun worship.

Pieces of the stone are held at St Luke's Church in Stocking Farm, but the stone itself has vanished. Its location is now a back garden near to Somerset Avenue in the suburbs off the city's Blackbird Road.

# St Mark's Church

Standing on the corner of Belgrave Gate and Foundry Square, this tall gaunt place of worship is Grade II listed and an important part of Leicester's Victorian social history.

The architect was Ewan Christian, who is most well known for his restoration of the cathedrals at Southwell and Carlisle. However, it is St Mark's that can lay claim to be his masterpiece, and with good reason. In its style and design, the use of materials and innovative plan, it stands out among them and ranks with the great churches of more famous Victorian architects.

It was built over a period three years from 1869 on a challenging site because the land narrowed on both the north–south and east–west perspectives. This would have accommodated only a relatively small church of cruciform shape unless the building could be 'bent' to fit the irregular shape of the land. Responding to the challenge, Christian placed the tower and spire at the south-east corner of the church and built three 'step backs' from that point towards the west end. He also needed to disguise the angled shape of the body of the church, which narrows towards one end, and he

Socialism amid Christianity. The remarkable socialist altar panels at St Mark's Belgrave Gate.

achieved this very effectively by disguising the angle or 'cant' by adding two small chapels projecting from the south aisle. A similar device was used on the opposite side.

The church is in the Gothic style and built of purple granite rubble with stone dressings and roofs of Swithland slate, which gives the church a gaunt and dominating presence. The building was financed by a gift to the people of the area by the Herrick family of Beaumanor Hall, Woodhouse, near to the where the Swithland slate was quarried.

Today the modern buildings around it are inconsequential, but the church was originally surrounded by large industrial buildings including foundries and textile factories, and was close to the canal wharf. Hence, in its day, its powerful presence was very much in keeping with its surroundings. The church was extended in 1903 and stained glass was added in 1893 and 1895. However, St Mark's is famous for one of its priests, Revd Frederick Donaldson who was one of the leaders of the Leicester March of the Unemployed to London in 1905, and who commissioned remarkable socialist-themed altar paintings that have survived but are now obscured by modern fittings.

# St Margaret's Church

Now standing by the side of St Margaret's Way, a modern dual carriageway, this is a stately and dignified church of impressive proportions that has one of the finest Perpendicular towers in Leicestershire.

Although St Margaret's is one of the historic ancient churches of Leicester, it is actually outside of the medieval walls of the city at the extreme north-east corner of the old town. It is the only Leicester parish church not to have been in the gift of Leicester Abbey, instead being under the jurisdiction of the diocese of Lincoln.

The present church is the third church to stand on this site. The first was a Saxon church established in 679. It was after the Danish invasions of the ninth century that

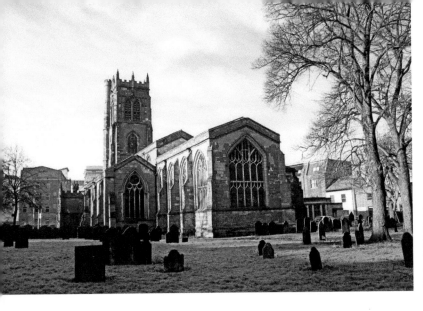

Religious tranquillity in the heart of Leicester. The ancient parish church of St Margaret.

jurisdiction passed to Lincoln. A significant programme of rebuilding took place in the thirteenth century and the tower and clerestory were added in 1444. The oldest work in the church can be seen at the east end of the north aisle where an excavated area is exposed to show the foundations and a well from the first building. In the chancel is the alabaster tomb of Bishop Penny, a former abbot of Leicester.

# St Mary de Castro

The parish church of St Mary de Castro was the chapel of the castle, and stands within its precincts. 'Castro' was added to its title to differentiate it from Leicester Abbey, which was also dedicated to St Mary and known as St Mary de Pratis. The history of this ancient and beautiful church is closely linked to the men who occupied the castle, and to their important visitors. It is said to have been founded in 1107 as a collegiate church with a dean and twelve canons and as a chantry chapel for the family of Robert de Beaumont and the first three Norman kings of England.

There is a popular claim that here, Geoffrey Chaucer married Philippa de Roet, who was a lady-in-waiting to Edward III's queen, Philippa of Hainault, and a sister of Katherine Swynford, later to become John of Gaunt's third wife. Henry VI was knighted in the church in 1426 as an infant while the famous Parliament of Bats was taking place inside the castle. At this time, tensions between the Duke of Gloucester, the young king's uncle, and Cardinal Beaufort led to concerns that violence could break out during the parliament. It was therefore decided that weapons would not be permitted within the Great Hall of the castle. However, some of the attending barons concealed clubs or 'bats' beneath their outer clothing.

The fine fourteenth-century slender spire, which had been rebuilt in 1783, was removed in 2013 because it was unsafe. The dangerous condition meant that the church and the surrounding area had to be closed for several months. Ironically, Victorian 'refurbishments' were the main reasons for its near collapse.

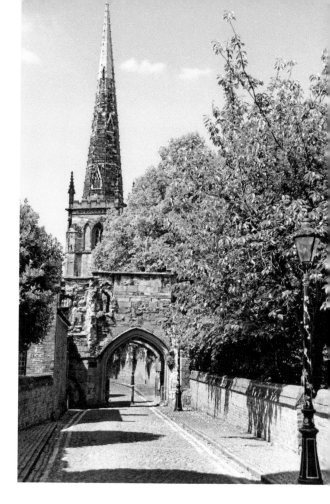

St Mary de Castro before the landmark spire was removed for safety reasons.

# St Nicholas Church

The parish church of St Nicholas has a history that perhaps has still to be fully discovered. There is general agreement that the church, or one of the buildings that preceded it, was the probable seat of the Saxon bishops of Leicester. Some parts of the present church date to AD 880 and its location within the town's former Roman structures, near to the centre of the town where the later principal streets cross, would suggest an appropriate place for the seat of a bishop.

The church was not always dedicated to St Nicholas. It may have originally been dedicated to St Augustine or St Columba, which was appropriate for a church located in the 'middle' (Mercian region) of England between the southern (Roman) and northern (Ionian) Christian traditions, whose opposing influences led to the Synod of Whitby in AD 664. This could suggest that a building existed here even before the known date of AD 880. It has been suggested that the church or its churchyard was the meeting place of the jurats of the town at the Jewry (or Jury) Wall, but there seems no reason to associate the area with the Jewish population of the town.

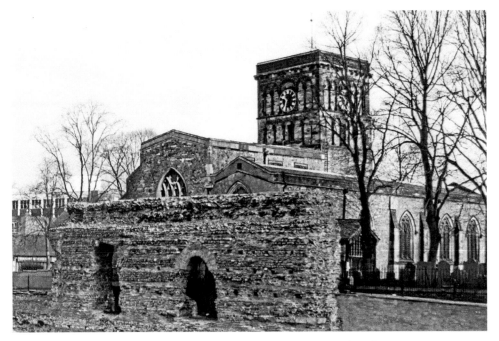

The parish church of St Nicholas is possibly the earliest Christian foundation in Leicester.

# St Nicholas Circle

Beneath the busy gyratory of St Nicholas Circle lies a pattern of medieval lanes. The 'circle' itself closely follows the lines of the earlier Redcross Street, which was the extension of Peacock Lane, and St Nicholas Street, which was the extension of High Street. Beneath today's Holiday Inn are the lines of Thornton Lane (extending Guildhall Lane) and Harvey Lane, a small street that linked Redcross Street with Thornton Lane. To the south ran another short street known as Bakehouse Lane. Inside this small area was a conglomeration of little houses, workshops, pubs and the famous Harvey Lane Baptist Chapel where William Carey, the Baptist missionary, preached.

In nearby St Nicholas Street, not far from St Nicholas Church, stood a very ancient house where it is said both William Carey and John Wesley stayed at some time in the past. Beneath that house was an extensive piece of Roman mosaic floor, which visitors could descend stairs to observe on payment of a small sum to the owner of the building. The mosaic is now in the Jewry Wall Museum.

Redcross Street was named after an old cross that once defined the centre of an ancient market and stood at the junction of this street and Applegate Street. It is conjectured that this was the meat market and relates to the nearby Holy Bones.

# River Soar

Leicester probably came into existence because of the nature of the river, not one main watercourse, but numerous tributaries and small islands that ebbed, flowed and altered their patterns with the changes in the seasons. It allowed wildlife to flourish, and gave easy access to fresh water. Much later, it gave rise to the Roman garrison, located where the Fosse Way crossed the river. After the Norman Conquest, the river was used for military defence, creating a western boundary for the town watched over by a motte-and-bailey castle. When the Industrial Revolution reached Leicester, its waters were used in many textile manufacturing processes.

The growth of industry and mechanisation created pollution. For many years, the boatmen who navigated the area called this the 'River Sewer'. Until the creation of Castle Park on land that had been used as a waste and refuse site by the Corporation, Leicester had turned its back on its river. Now, the award-winning gardens are part of 8 miles of linked green spaces, wildlife areas, historic features and industrial heritage along the river and the Grand Unions Canal. The paths connect major tourist attractions including the National Space Museum and Abbey Park. A new footbridge now spans the river near the old West Bridge, and the waters are now so free of pollutants that wildlife has returned including otters, ducks, moorhens and swans.

The River Soar, once polluted by industry but now a wildlife haven.

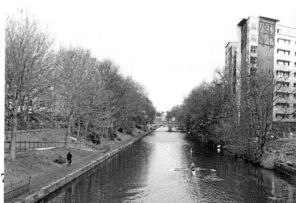

The River Soar from Newarke Bridge, looking towards the 'One Mile Straight'.

# Southgates

In medieval times this was the continuation of Highcross Street towards the south gate of the town. Today it is part of the central ring road, and is most familiar to Leicester residents as the name of the underpass that was tunnelled under the oldest part of the town beneath St Nicholas Church and today's St Nicholas Circle.

In Leicester, the medieval south gate was not in the middle of the south wall (and therefore opposite the north gate) but offset to the west nearer to the castle, which guarded the south-west corner of the town, but archaeology suggests that there was an earlier exit to the town where one would expect to find it. This is possibly where the Gartree Road began, which then tracks south to the Leicestershire village of Medbourne and then to Godmanchester near Cambridge, and on to Colchester. So today, although now a dual carriageway, the modern Southgates still sweeps to the west and respects the path that thousands of merchants and traders followed as they brought their goods to and from the market at the High Cross.

Nearby stood a large covered bus station operated by the Midland Red Bus Co. After its demolition, and before construction of new student accommodation commenced, the University of Leicester Archaeological Services (ULAS) undertook a survey of the land. A remarkable amount of detail of Leicester's Roman past was uncovered including a substantial boundary wall, a large quantity of late Roman coins and two gravelled streets, one of which had not previously been recorded.

# Tanky Smith

On the western side of London Road, above and opposite Devonshire Place, is Top Hat Terrace, originally known as Victoria Terrace and built in 1864. It acquired its unusual name because of the sixteen stone heads along the front of the building. The nickname is from the top hats worn by the police until 1872, but all sixteen of the effigies on this façade represent a certain Detective Inspector Francis 'Tanky' Smith in his various disguises.

Tanky Smith was the first detective to be appointed when the Leicester Police Force was formed in 1836. With a colleague, Tommy Haynes, Tanky is credited with significantly reducing the amount of petty crime in the town. He became a master of disguise and successfully infiltrated criminal gangs to secure incriminating evidence.

When he retired from the police force, Smith became a private detective. His most well-known assignment was being hired by the Winstanley family of Braunstone Hall to find James Beaumont Winstanley, who had disappeared while touring in Europe. Tanky was richly rewarded for his efforts and invested his money in building a Victorian terrace on London Road and in developing Francis Street in Stoneygate.

Top Hat Terrace was designed by Tanky's son, James Frances Smith, as a tribute to his famous father. The terrace was refurbished in 1987, funded by a grant of £7,700

Victorian policeman turned private eye,
the remarkable Tanky Smith.

from Leicester City Council and remains a fine commemoration of an unusual and
remarkable man.

# Richard Toller & Toller Road, Stoneygate

Richard Toller was a distinguished lawyer. He was born in 1805 and after being
articled to a legal firm in Kettering he moved to Leicester in 1827 where he set up his
own practice. Originally established in Cank Street, the firm later moved to nearby
Wycliffe Street. From 1836 until his death in 1896 he served as clerk of the peace to
the Leicester Quarter Sessions. He was also appointed, in 1851, to be a 'Perpetual
Commissioner for taking the acknowledgment of deeds to be executed by married
women in and for the county of Leicester'.

He purchased Stoneygate House, one of the first residences in the area, from a
wealthy grocer, Thomas Nunneley, and gave his name to the road, along which other
properties were soon built. His sons continued his legal practice and were joined
by other partners. The name lives on in the Toller-Staunton Group, which was in
Leicester until 1974.

Toller Road is not a thoroughfare and is one of the many unnoticed roads in this area
through which the busy London Road runs. Although there has been much rebuilding

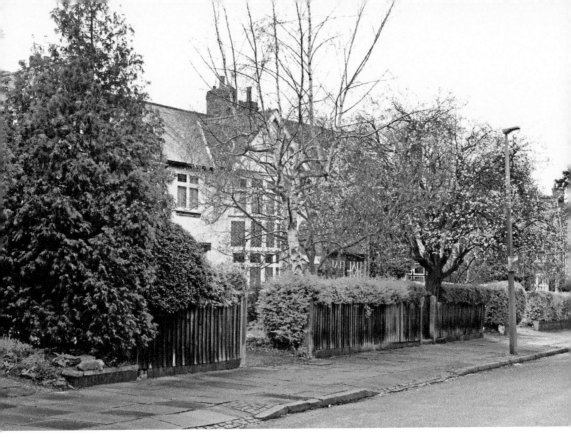

Toller Road, Stoneygate, named after lawyer Richard Toller.

and infilling, the early spacious dignity of the road that Richard Toller enjoyed is still apparent, especially in the large houses on the northern side of the road, standing back on spacious plots of land. Several of these have been converted into apartments, or are being used as care homes.

# The Town Hall and Town Hall Square

Leicester's Town Hall is easily missed because it is set away from the main thoroughfares in a relatively quiet corner of the city centre. It was built on the former cattle market to replace the old Guildhall. It was designed in the Queen Anne style by the London architect Francis Hames (1850–1922) and opened in 1876. Unlike some of its more austere counterparts, particularly in England's northern cities, Leicester's Town Hall has a sense of warmth and welcome. Built on a slope, the inclusion of a tower containing a turret clock rising to 145 feet in height at the lowest point of the building provides subtle architectural balance.

The building was needed because the Guildhall, which had been used by the Corporation for over 300 years, could no longer accommodate its expanding activities, and it was also designed to include the local judicial processes with court rooms, cells and retiring rooms for judges. Town Hall Square is a popular lunchtime meeting place for local workers, surrounded by Bishop Street Methodist Church and other Georgian, Victorian and Edwardian buildings of great dignity. The fountain in the centre of the square was donated to the town by Sir Israel Hart, a former mayor and high bailiff, in 1878 in order to maintain the area as a public open space for all time.

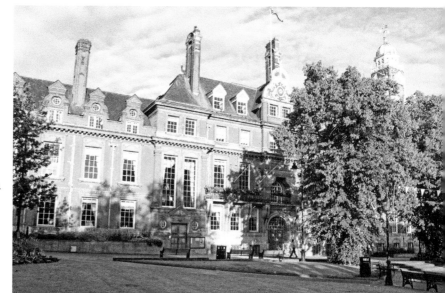

Dignified yet modest, Leicester's Town Hall is a fine and welcoming building.

# Trinity Hospital

In 1330 Henry Plantagenet, 3rd Earl of Leicester and Lancaster, commissioned a hospital to treat the poor and the infirm of the town. It was built on land near the castle precincts. Originally called the Hospital of the Honour of God and the Glorious Virgin and All Saints, it became Trinity Hospital in 1614. The building was reconstructed in 1776 and again in 1901, but the original medieval chapel has survived.

The hospital had room for fifty poor and infirm people, of whom twenty were permanent residents. There was also accommodation for four chaplains and five female nurses. The chaplains were supposed to 'avoid taverns and the market place', and the nurses were to be of 'good fame and untarnished reputation'. However, in the centuries that followed there were repeated accusations of impropriety and malpractice.

The building was probably damaged during the Civil War when the Royalists defeated the Parliamentarians in Leicester, the fiercest fighting being in the Newarke, but the gravest threat to its existence came with the post-Industrial Revolution expansion of Leicester. In the final years of the nineteenth century, the Corporation announced plans to demolish the hospital to make way for a new road and bridge connecting the town, the Newarke and the expanding West End. In the wake of one of Leicester's earliest conservation campaigns, a compromise plan was adopted. The medieval chapel at the eastern end of the building and some of the bays were saved, but the rest of the hospital was demolished and rebuilt at an angle.

The building is now owned by De Montfort University and houses part of the university's administrative offices, and music is still performed in the chapel from time to time. The work of Trinity Hospital, Leicester's oldest charitable foundation, continues on a modern site by the riverside on Western Boulevard.

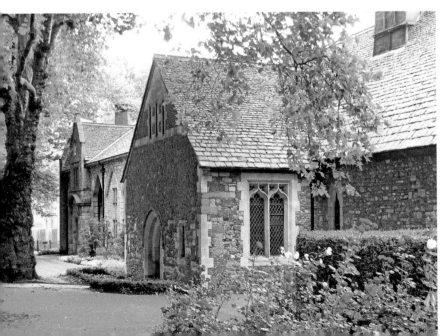

Trinity Hospital, formerly part of the Newarke College.

# Tycho Brae Mosaics

In the 1960s, Leicester City Council commissioned East Midlands artist Sue Ridge to design a series of colourful mosaics to cover the pedestrian subways that linked the Newarke and the city beneath the central ring road. Sue took her inspiration from the work and life of the sixteenth-century Danish astronomer Tycho Brahe.

Born in 1564, Brahe made a catalogue of over 1,000 stars. His work was remarkably accurate for his time and had an impact on research, which remains today. In May 2011, NASA issued an image of 'Tycho's Supernova remnant'. This same body was referred to by Shakespeare in *Hamlet* as 'yond same star that's westward from the pole'. Tycho Brahe made precise observations of the star, which was later to be named after him.

Brahe's observations were revolutionary, and provided confirmation of a dynamic universe. This was against the prevailing belief that all celestial bodies were fixed in place.

One of Sue Ridge's larger mosaics depicted Brahe's early view of the universe, the moon revolving around the earth, the planets revolving around the sun, and stars on the edge of the known universe.

Over time, graffiti and anti-social behaviour had made the area an unpleasant place, especially at night. The network of subways was filled in. The mosaics now lie buried beneath many tons of rubble.

Now buried beneath tarmac, these ceramics were based on the work of astronomer Tycho Brae.

# Unitarians

The 'Great Meeting', in the shadow of the Highcross Centre, represents 300 years of 'freedom, reason and tolerance'. It is the home of the Leicester Unitarians. It was built in 1708 and claims to be the oldest complete brick building in the city.

The history of the building and those who have worshipped within it dates back even further to the early followers of a Presbyterian sect who in 1680 were given a licence to meet in a barn near to where the Leicester Royal Infirmary now stands. Two years later, the early Congregationalists were known to be meeting in another barn near Millstone Lane. They came to share the same minister, and to be united in their beliefs. As the congregations grew, a permanent church was needed, and the Great Meeting was built. The form of worship in the church became Unitarian at the beginning of the nineteenth century, and its members became a very strong influence on the political and civic life of the city.

In essence, Unitarianism is a Christian denomination that takes an open-minded and individualistic approach to religion, and allows for a very wide range of beliefs and interpretations. Everyone is free to search for meaning in life in a responsible way and to reach their own conclusions.

The Unitarian's 'Great Meeting' chapel in East Bond Street.

In 1835 the Municipal Reform Act paved the way for a dramatic change in how Leicester was governed. The 'old guard' of the previous Corporation was rejected, making way for a group of enlightened and responsible leaders, many of whom came from the ranks of the Unitarians and were industrialists, businessmen, entrepreneurs, and benefactors.

# Union Street and
# the Co-operative Society

In the twentieth century, Gallowtree Gate became the centre of Leicester's retail trade, continuing a trend that had begun centuries earlier when the focus of the town began to move east, away from the old High Cross.

A notable exception to this trend was the Co-op, whose large and rambling store in the middle of High Street is still missed by many local people. It was built in 1885 on the corner of High Street and Union Street, but its actual address was No. 4 Union Street, with the goods delivery bays located in Freeschool Lane. The store had numerous departments including ladies' fashion, menswear, food, and house and garden items.

The store held steadfastly to its traditional style of trading right up to 1985, when the Leicestershire Co-operative Society announced it was selling the freehold on the land. Three years later the building was demolished to make way for the Shires Shopping Centre. In an imaginative architectural step, the familiar and impressive façade of the store, along with almost all the Victorian and Edwardian frontages on the north side of the High Street, were retained and incorporated into the new centre.

Union Street vanished at this time. The Shires Centre was later redeveloped and extended to create the Highcross Centre of the present day. One of the entrances to the centre from High Street is near the former location of Union Street.

The Co-op in its finest hour. Grand architecture in Leicester's High Street.

# Victoria Road Church

This impressive building represents a failed Victorian experiment in ecumenism. A dynamic group of 'modern' Baptists believed that salvation was not exclusive to them and that all should be welcome to worship with them. The result was a church – not a chapel – built in the English Decorated style with stained-glass windows, and looking like a 'traditional' Anglican church.

The architect, John Tarring of London, made excellent use of the limited space available to create a building that looks larger and taller than it really is. Even today, despite high-rise modern buildings, the spire dominates the skyline.

It was known simply as the Victoria Road Church, the intention being to attract both residents who would normally attend an Anglican church, and those of Nonconformist beliefs. The first service was held on 6 January 1867, and in the years that followed, the congregation steadily but slowly increased. Several influential Leicester men joined the nonconformist ranks including Edward Wood, the founder of the footwear business Freeman, Hardy and Willis. It was a 'comfortable' conservative church; a Baptist church for Anglicans, middle class and fairly wealthy.

The church continued for many years, but closed in the last decade of the twentieth century. The building was purchased by the Seventh Day Adventist Church and is now their Leicester Central Church.

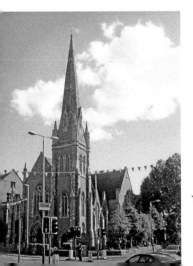

Victoria Road Church, a failed experiment in ecumenism.

# W

## Western Park

Western Park, as its name suggests, lies to the west of the city and is Leicester's largest park, occupying 178 acres of land that was purchased by the Corporation in 1897 for £30,000. The surrounding residential area shares its name. The park was landscaped to provide a variety of views and vistas while retaining a sense of the countryside. The woodland, meadows and more formal areas combine to create a haven for a wide variety of fauna and flora. Today it also provides a range of sporting activities including bowling greens, football and cricket pitches and tennis courts. Since 2008, the full-sized baseball field at the south-west end of the park has been the home of the Leicester Blue Sox Baseball Club, who have been British Baseball Federation national baseball champions in 2009 and 2012.

The former park warden's lodge in the park is the headquarters of Groundworks Leicester and Leicestershire, an environmental charity. The building has been refitted several times to demonstrate how homes can become more environmentally friendly. It is occupied by a tenant but is open to the public on some occasions. The park also has a cycle trail. In the summer, local brass bands entertain visitors at the bandstand, and there is a summer community festival.

It is said that Leicester's notorious witch Black Annis lived in a cave near here from where she used tunnels to enter the town to seize small children.

## Wharf Street Telephone Exchange and Post Office

As business expanded after the Second World War, so too did the demands on Britain's telephone system, which was still largely dependent on exchanges built in the Victorian period. In Wharf Street, the architect of the General Post Office saw the opportunity to incorporate a branch post office into and to introduce a new innovation – the first drive-through post office service in the United Kingdom.

The new building was opened on 11 December 1959. The architectural historian Nikolaus Pevsner mentions it briefly in his Leicestershire guide, describing it as

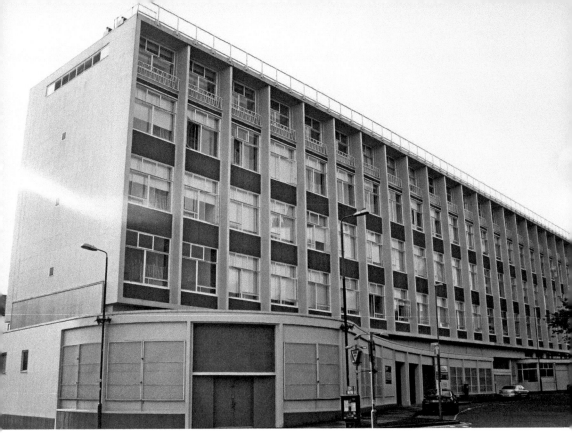

The former Wharf Street Telephone Exchange.

'a substantial modern building, five storeys, 27 bays, large three-light windows. The ground floor projects in an irregular curve and is also mostly glazed.'

The building also had a private road running through it from Lee Circle to Wharf Street to provide the 'drive-through' facility. This road is very near the line of the earlier Lee Street, the northern end of which can be seen as a small turning off Bedford Street behind the Job Centre. It is on the site of No. 50 Lee Street, where Joseph Merrick, also known as the Elephant Man, was born in 1862.

The drive-in facility was not a success. The mechanism used by cashiers to pass letters and other items through to drivers often broke down, and the road created a wind tunnel that made communication difficult, as well as blowing stamps and other lightweight items. The building has been converted into apartments and is now known simple as the Exchange.

# James Kemsey Wilkinson

No. 151 Charnwood Street, in a cluster of local neighbourhood shops known to many in the area as 'old Charny', was the location of J. K. Wilkinson's first shop.

Wilkinson and his fiancée Mary Cooper opened their first shop in 1930. James' brother Donald was already running a hardware store in Birmingham, and the two

V

James Kempsey Wilkinson, founder of the Wilko
retail chain.

brothers worked together to acquire stock. Two of Donald's Handsworth stores were
later to join the main Wilkinson chain.

In 1932 the Wilkinsons opened their second shop – in Wigston Magna – and the
couple were married in 1934 at St Peter's, Highfields. Family legend holds that the
wedding took place at 8 a.m. to enable the young couple to be back at the shop by
11 a.m. In 1938, another brother – John – joined the business and in the following year
offices and warehousing space was acquired in the Syston area. Six more stores were
opened by 1939.

J. K. served with the Royal Armoured Corp during the Second World War, leaving
his brother John to manage the company. Three of the shops were forced to close
during the war but reopened in 1948. The growth in popularity of DIY in the post-war
decades greatly assisted the chain to expand. In 1958 their largest store at that time
was opened in Leicester's Charles Street, with J. K.'s son Tony as the manager. It traded
until the 1990s when even larger premises were secured further along Charles Street
at Epic House.

The Wilko group now has over 400 stores. J. K. – as he was familiarly referred to
within the company – remained closely associated with the business until his death
in 1997.

# Wygston's House

In medieval times, Highcross Street was where many of Leicester's wealthiest citizens
were likely to be found, living and trading. Wygston's House, now overlooking the
recently laid out Jubilee Square, is a fine example of the kind of high-status residence
in which these prosperous men lived.

It is generally agreed that this was the house of Roger Wygston (which is how he spelled his name in his will). He was mayor of Leicester on three occasions between 1465 and 1487, served as the MP for Leicester in 1473 and 1488, and died in 1507. His initials can be seen in ten of the twenty-nine panels of stained glass, dating to 1490, which were in the north-facing windows of the house until they were removed in 1824. Roger Wygston was probably an uncle of William Wyggeston, who is commemorated on the clock tower for his philanthropic work.

This ancient building has survived because it was protected by the construction of a later building facing Highcross Street, which protected it from damage and development. It has been used for a variety of purposes since it ceased to be a residence. It was the city's Costume Museum for many years before being leased to several community groups and charitable organisations. After remaining empty for nearly a decade, in January 2016 Leicester City Council leased the building to a business that would use the building as a bar and restaurant serving an English menu, and was willing to work with local heritage groups to protect this amazing building, once the home of one of Leicester's important citizens.

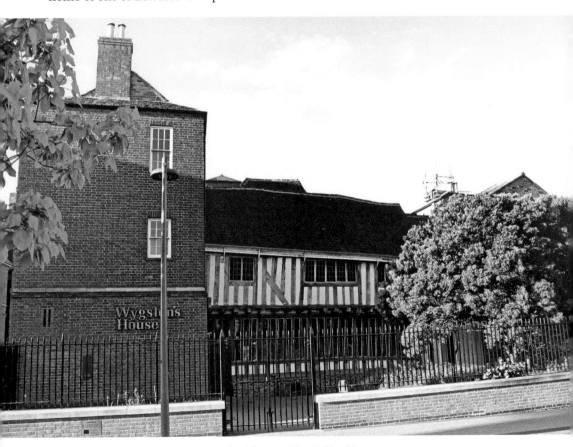

Thomas Wygston's house, Leicester's oldest residential building.

# Iannis Xenakis

When Eric Pinkett, the first county music advisor in England to be appointed by an education authority outside London after the Second World War, decided to create a training orchestra made up of the finest of Leicestershire's music students, he also established a policy of working with contemporary composers.

At about the same time, Iannis Xenakis, who was one of the foremost young composers of the period, fled Greece, fearing for his life as the Greek government began arresting former resistance members, particularly those who were left-wing oriented. Xenakis escaped to Paris through Italy and reached safety in Paris.

Condemned to death in the country of his birth, Xenakis remained in France, composing and conducting his music. In 1977 the Leicestershire Schools Symphony Orchestra recorded his complex *Jonchaies* on an album that also included works by Douglas Young, Leicestershire's composer-in-residence who had studied Xenakis and had been greatly influenced by him.

Xenakis died in 2001. His music, which ranges from the chaotic sounds of war and thunderstorms to the spiral forms that occur throughout the natural world, and is often based on mathematical probability, is still being studied and performed in Leicester, now by students and staff in the Music Technology Department of De Montfort University.

Iannis Xenakis, whose work was embraced by Leicestershire music students.

# The Y Theatre

Originally built as a Christian lecture hall, the Y Theatre is the oldest surviving theatre in Leicester, and dates from 1900. Although hidden from view inside the larger Y Centre, it is a busy live performance venue presenting music, comedy, theatre, dance and spoken word. It also plays an important role in the wider activities of the 'Y' as a space for courses, classes and workshops.

The Leicester YMCA began in premises in Market Place in 1883, with Thomas Howard Lloyd as president. Albert Sawday became president in 1896 and designed the new baroque-style home for the YMCA. The Association Hall was opened by the Marquis of Northampton on 5 December 1900. Sawday, who as an architect was responsible for many Leicester buildings, was mayor in 1903.

Over 1 million servicemen are said to have used the Leicester YMCA's facilities across the city during the years of the First World War, and more than 1,200 members of Leicester YMCA went on active service.

After the war, Sir Jonathan North, then Leicester YMCA's patron and mayor of Leicester, launched an appeal to save the Leicester organisation, which was facing a debt of £20,000 and had been threatened with eviction. The War Memorial Fund was successful in securing the future of the building and its famous theatre.

The centre was refurbished in 1981 and reopened by HRH Prince of Wales when Leicester's YMCA became a housing association. The building was Grade II listed in 2001, and in the following year, the Y Theatre relaunched as a professional theatre, music and comedy venue.

# Z

## The Zenith Building

The regeneration of the Rutland Street area, which is now Leicester's Cultural Quarter, has involved finding new uses for redundant factories and warehouses, and adding new buildings to provide contrast but give space and context to the old. The award-winning Zenith Building is one of these new successful additions to the city landscape that are key to encouraging people to live in the city centre and to bring life and vibrancy to the area.

Although owned and managed by companies outside the city, the Zenith Building has a strong connection with several of the Victorian and Edwardian buildings nearby. It was designed by Goddard Manton, a practice which has its roots in Leicester's architectural 'golden age' when Joseph Goddard (1751–1838) founded a practice in Leicester in 1834, the same year as RIBA (Royal Institute of British Architects) was set up. Many of the most well-known buildings in Leicester, including the iconic clock tower, the former Midland Bank in Granby Street and the Irish Menswear building on the corner of Silver Street and High Street, were all designed by members of the Goddard family.

# Acknowledgements

The history of Leicester is well documented, and any new writing about the city must acknowledge the antiquarian historians of the seventeenth and eighteenth centuries, particularly John Nichols, and respect the many historians who followed.

It is possible that at its two universities, Leicester has more local historians than any other English town or city. Its eminent societies include the Leicestershire Archaeological and Historical Society whose annual transactions have been a reliable source of reference since 1855, and the Leicester Civic Society, which is recording and commentating on the Leicester of today.

I must acknowledge several sources of the present age who have contributed photographs, advice, criticism and information. These include Jonathan Calder, Tony Wilkinson (former chairman of Wilko Plc), the University of Leicester Special Collections, the archives of De Montfort University, the *Leicester Mercury*, Everards Brewery and BBC Radio Leicester. I have also drawn on the work of other authors, past and present, who have written about the buildings, locations and people included in this book. These include Professor Jack Simmons, Malcolm Elliott, Dr Alan McWhirr, Richard Gill and Ben Beazley. Their own important published contributions to our understanding of Leicester are still available and highly recommended.

# About the Author

Stephen Butt was born and grew up in Weston-super-Mare in Somerset and gained his first degree from Durham University. He worked as a studio manager with the BBC at Broadcasting House and the BBC World Service before moving to BBC local radio and finally BBC Radio Leicester, where he presented and produced a broad range of programmes. Later he became a senior broadcast journalist and joined the station's management team.

He now enjoys writing and historical research, with over twenty books in print that combine an academic background in local history with a practical interest in photography. Stephen's BA degree was in psychology and his MA degree is in English local history (University of Nottingham)

During 2009/10 Stephen provided production and location research support for Michael Wood's major BBC television series *Story of England* for which he organised the Kibworth Dig involving local families in digging more than fifty archaeological test pits. He also worked on Mayavision International's *Great British Story: A People's History*, which was broadcast on BBC2 and BBC4 in summer 2012.

Stephen has served as honorary secretary of the Leicestershire Archaeological and Historical Society. In 2016 he was commissioned by Leicester City Council to provide the research for a series of heritage panels to be installed at locations throughout the city. He holds the certificate in local government administration and works as a parish clerk for two south-Leicestershire parishes. He has also co-produced and directed several short corporate videos for local government.